WALKS IN PICASSO'S BARCELONA

WALKS IN PICASSO'S
BARCELONA

Mary Ellen Jordan Haight
and
James Jordan Haight

PEREGRINE SMITH BOOKS

SALT LAKE CITY

*For Raymond, husband and father,
with love and appreciation for his
faithful encouragement and
captivating enthusiasm.*

First edition

95 94 93 92 5 4 3 2 1

This is a Peregrine Smith Book, published by
Gibbs Smith, Publisher
P.O. Box 667
Layton, UT 84041

Cover production by Larry Clarkson
Interior production and maps by Mary Ellen Thompson

Cover photos:
Pablo Picasso, courtesy Réunion des Musées Nautionaux
Casa Milà (upper right), James Jordan Haight
Temple de la Sagrada Familia (bottom), courtesy Archive Càtedra Gaudí

Manufactured in the United States of America

Library of Congress Cataloging-in-Publication Data
Haight, Mary Ellen Jordan.
 Walks in Pacasso's Barcelona / Mary Ellen Jordan Haight
and James J. Haight.
 p. cm.
 Includes bibliographical references (p.125) and index.
 ISBN 0-87905-451-4 (pbk.)
 1. Art, Catalan--Spain--Barcelona. 2. Art, Modern--20th century--
Spain--Barcelona. 3. Barcelona (Spain)--Description--Guide-books.
 I. Haight, James J. II. Title.
 N7111.B3H35 1992
 709'.46'720904--dc20 91-37906
 CIP

CONTENTS

SETTING THE SCENE

"All Picasso's roots are in Spain," pointed out art historian John Richardson, "but one also has to establish the link between those roots and what happened in the end, because Picasso comes full circle. Those last engravings he did in the sixties refer right back to Málaga and Barcelona and Spain."

The vivid red and yellow of the Spanish flag represent sand and sun, but the colors could also describe the brilliant flame of Catalan patriotism. The Catalans of Barcelona, the capital of Catalunya, are fiercely proud of their heritage; they speak the Catalan language—a mixture of Spanish, Moorish, and French influences—along with Castilian Spanish, and street signs read in both languages. Barcelona is a graceful blend of a modern city, with its attendant excellent transportation and hotels, superb restaurants, ancient churches, and international port adjoining an aged Barrio Gótico (Gothic district) and the former Chinese quarter, where seamen sought evenings filled with forbidden pleasures.

Visiting a foreign city, whether in person or by armchair, can be made more interesting, meaningful, and exciting when approached through the historical and cultural chronicle of the people. Soaking in and absorbing the ambiance means walking, sitting on a park bench, attending a theater performance, inhaling the fresh smells in a market, and unhurriedly viewing the museums. The mild weather of Barcelona plus photogenic boulevards and small winding streets extend an invitation to stroll and to sample the delicate aromas of semitropical flowers mixed with the delicious smells of the vibrant cuisine, a mixture of northern Italian, French provençal, côte d'Azur, and simple Spanish country cooking that uses the freshest ingredients: shellfish, cheeses, and indigenous wines.

If history chooses one field in which Spain has contributed to the culture of civilization, it would be in the arts; and modern Barcelona is the focus for the arts in Spain. In the late nineteenth century, the works of painters Ramón Casas i Carbó (1866–1932), Isidro Nonell i Monturiol (1873–1911), and Santiago Rusiñol i Prats (1861–1931) clearly reflected the new currents of European art when Spanish sculptors Miquel Blay, Josep Llimona, Josep Clarà (1878–1958), and Enric Casanovas (1882–1942) were beginning to acquire international fame. Barcelona's reputation as the mother of revolu-

tionary twentieth-century art spread through European art circles as Catalan modernists Pablo Ruiz i Picasso (1881–1973), Salvador Dalí (1904–1989), Joan Miró i Ferrà (1893–1983), and Antoni Tàpies (1923–) exhibited their unique projects executed in a variety of media. Pablo Ruiz i Picasso, born in Andalusian Málaga, was the embodiment of the history of Spanish painting and sculpture as he continued the tradition of Velázquez and Goya when making the greatest use of the temperament and mind of the Spanish people. According to John Richardson, "Almost every artist of any interest who's worked in the last fifty years is indebted to Picasso whether he's reacting against him knowingly or is unwittingly influenced by him. Picasso sowed the seeds whose fruits we are continuing to reap."

Another cultural element intimately associated with the Catalans is music. Music can be heard in Barcelona on every corner at every hour of the day. As far back as the Middle Ages, the nobility permanently employed musicians to entertain. The municipal band and the school of music were founded in 1886. Catalunya is a land of internationally renowned musical artists such as opera stars Montserrat Caballé, Victoria de Los Angeles, tenor José Carrera, and the late cellist Pau (Pablo) Casals, who composed the "Hymn to the United Nations." The popular strolling groups that sing on the sidewalks and in taverns were first organized in the mid-nineteenth century. Another musical tradition is the brass band that accompanies the dancers of the *sardana,* Catalunya's national dance.

On your first venture along the wide, tree-shaded sidewalk of the Passeig de Gràcia, expect to be shocked and amazed at the Moderniste buildings designed by Antoni Gaudí i Cornet (1852–1926) and his colleagues. These fantastical structures will leave you with an image not only of today's modern Barcelona, but also a conception of the appearance of the community when Picasso and his fellow artists and writers struggled for recognition. Barcelona, Paris, and Vienna were the three glittering capitals of nineteenth-century style, but most Catalan architects and designers were little known outside of Spain. Most renowned from this earlier period are Gaudí, Josep Puig i Cadafalch (1867–1956), and Lluís Domènech i Montaner (1850–1923), the core group associated with the Modernisme movement that paralleled the Italian Stile Liberty, British and French Art Nouveau,

American Modern style, and German and Austrian Secession movements.

Modernisme in Catalan Spain had its own very strong personal identity that distinguished it from these other closely associated movements by two pronounced characteristics. First, Modernisme was characterized from the outset by its widespread popularity that sprang from its remarkable identification with the social and political realities of Catalunya during this historical period, which identification and relationship allowed it to embrace, within one coherent approach, everything from poetry to economics. Second, Modernisme included a stylistic complexity combining Catalunyan Romanticism and the pre-Raphaelite world of John Ruskin, allowing for the coexistence and reinterpretation of the revivals of the social and ethical reforms of the Arts and Crafts movement. The resultant floralizing of structures to the point of delirium promoted the evolving rationalist machine-worship that was part of mechanization after the turn of the century. The movement encouraged the most advanced and revolutionary expressionism to develop simultaneously in the decorative arts and technical sciences. "We are Catalans. We don't have to be Greeks, Gothics or Egyptians. We must be everything at once!" proclaimed Gaudí.

THE HISTORY

Linked closely to the Mediterranean Sea, whose lands were the cradle of Western civilization, Barcelona has deep historical roots. Evidences of residents as long ago as five thousand years have been unearthed. In 218 B.C. Amilcar Barca of the ruling family of Carthage founded a culture at Barcino or Barcinona (Barcelona). The colonization of Spain by the Roman Empire made Barcino a Roman colony in 133 B.C., and by the second century it had grown to ten thousand inhabitants. Spain had become an important division of Roman civilization, where the colonials adopted Roman engineering, law, currency, culture (including architecture), and language. Barcelona flourished economically as a prosperous commercial and maritime center. Then, one after the other, the Vandals, Visigoths, Moors, and, in the eighth century, the Frankish emperor Charlemagne invaded the large area south and east of the Pyrenees that would later become Catalunya.

One of the first counts under the jurisdiction of the king of Aquitaine created the dynasty of the House of Barcelona that was to rule the new nation for centuries. Ramón Berenguer I, in the tenth century, united the rest of the Catalunyan counties. In the twelfth century, Ramón Berenguer III (the Great) transformed the County of Barcelona into a western Mediterranean power through his marriage to the Douce de Provence, and that area of France now known as Provence was incorporated into the evolving Catalan state. His son, Ramón Berenguer IV, married Betrollina of Aragón and the Catalan dynasty of the Crown of Aragón was created. In the thirteenth century, under the reign of James I of Aragón, Catalunya became an independent state with its governing body within the city of Barcelona, and an enterprising urban middle class increased in prestige and economic power.

When the Catholic monarchs Ferdinand V (the model for Machiavelli's *The Prince*) and Isabel I of Castile came to the throne of Spain, the Catalan line of succession within the crown of Aragón ended with the emergence of Castile as the dominant power. Upon returning in 1493 from his first voyage to the New World, Columbus was received in Barcelona by these two rulers. By 1513, after two decades of exploration and conquests in the Americas, a completely unified Spain became the first modern and centralized state in Europe and the preeminent power of the Western world. During this golden age of Spain, relations between Barcelona and the crown were excellent and Catalunya's autonomy and institutions were respected. Art and literature prospered for nearly a hundred years and there was an explosion of baroque architecture, with the façades of buildings elaborately decorated with wreathed columns and reliefs using motifs of plants, flowers, and animals. But with the defeat of the Spanish Armada by the powerful British fleet in 1588, Spain's decline from imperial power began. The brutality of the Inquisition, intended to arrest the rise of Protestantism, drained the creative energies of the country.

By the middle of the eighteenth century, Catalunya had lost its unique political personality; its traditions and its language were nearly discarded. Still, despite being a province subject to the laws and dictates of the Spanish state of Castile, Catalunya blossomed with increased trade and a corresponding expansion of the textile industry in response to the emigration of Catalans to the new Spanish America with its expanded markets in the Western Hemisphere. Within sixty

years, the area's population doubled to a total of 870,000 inhabitants, the cotton industry alone employing over 80,000 workers. The accompanying massive investment in agriculture, including vineyards, allowed the expanding and more powerful bourgeoisie to enjoy a living standard practically unknown in the rest of Spain. By the turn of the twentieth century, a period of renaissance in the arts, from crafts to architecture, blossomed throughout Catalunya while the rest of Spain sank into a decadence that culminated with its defeat in 1898 in the Spanish-American War.

During its period of rebirth and social and political focus, Catalunya standardized and modernized its language; established a university and a scientific system of research, education, and production; and stimulated and promoted many ambitious cultural projects. Museums and galleries flourished, while literature became exceedingly preoccupied with style and form. The Moderniste architecture, based on the traditions of its past wedded with the new rationalism and industrialism of this period, was an artistic expression of the whole Catalan recovery. Dalí, a few years later, exclaimed, "The Catalans do not deform reality; they transform it." The first openly nationalist generation of Catalan society embraced Modernisme as the hallmark of their own self-identified, unique style. It was highly popular and specific to Catalunya. Unfortunately, it is difficult to find examples of the Moderniste movement in Spain outside the environs of Barcelona. In 1932, Catalunya was granted autonomy. The revolutionary civil war of 1936–39 split Spain into three major battling parties and inspired Picasso, a Republican supporter, to paint the monumental canvas *Guernica*. He named the painting for the defenseless Basque town that was bombed unmercifully by German-built planes in support of Spain's Fascist troops led by General Francisco Franco. Picasso vowed that the controversial painting would never hang in Spain until freedom was restored. In 1981, after forty years of exile in New York, the work found a permanent home in a separate building at the Prado Museum in Madrid. Barcelona's autonomy was abolished in 1938 when the right-wing military captured the city. The early years of Franco's dictatorship, which lasted from 1939 to 1975, were especially repressive to the Catalan language and culture. With Franco's death in 1975, his appointed successor, King Juan Carlos I, began his reign over Spain's transition to democracy. The

modern democratic socialist party which has governed Spain since 1982 has granted axiomatic autonomy for Catalunya and the Basque regions.

The quick development of democracy and the remarkable social and economic gains achieved in the relatively few years since Franco's death are dramatic. Now a member of the European Common Market and NATO, in 1992 Spain hosts both the Summer Olympics in Barcelona and the International Exposition in Seville in the year of the five hundredth anniversary of Columbus's discovery of America. The beautiful queen city of the Mediterranean has restored and cosmetically refurbished her majestic buildings, shady broad boulevards, and 150 expansive flower-filled public plazas and has constructed a dozen new sculpture-filled parks. From the Barrio Gótico, up Las Ramblas (called "the most beautiful street in the world" by Somerset Maugham) with its center island a maze of flower sellers, chirping birds, and stylish strollers in the evenings and Sunday afternoons, to the Passeig de Gràcia with its chic shops rivaling the rue du Faubourg Saint-Honoré in Paris, you will discover a society centuries old but rivaling Italy and France in modernity and style. The Mediterranean mélange of Italian, French, and Spanish is reflected in the culture of Barcelona. It is no secret that the Catalan apparel and house furnishings designers are beginning to challenge their counterparts in Milan as they create a unique style.

DINING CUSTOMS

Usually just coffee and milk and a roll are eaten for breakfast. Lunch does not even get going until at least 2 P.M. You will most definitely find yourself practically alone in a restaurant if you plan to eat dinner before ten o'clock. If your stomach won't wait, the delicious small *tapas* served at bars will tide you over, or they can make a whole meal. Waiting for dinner is a good time for strolling on Las Ramblas and watching the other paraders. Clubs open after dinner, often at midnight. After a couple of days on this schedule, you will understand why the afternoon siesta is a must—and, moreover, because of the hot afternoons during the summer months, the heat of the day allows for little else.

HOW TO USE THIS BOOK

Experience the joys of rambling or strolling with a purpose. Slowly absorb the ambiance, take time to sit in the parks and to linger over meals. Live like the Catalans do. The six walks plus a day in the colorful small seaside town of Sitges, about forty minutes by train from Barcelona, are planned to increase your interest and enjoyment of this unique and colorful area of Spain. We have listed the street and place names in Catalan. Most of the street signs are in either Spanish or Catalan; it won't be long before you understand some words. In Spain, the children are given the family name of their father followed by "i" ("and" in Catalan) and the mother's family name. For example, Picasso's formal name was Pablo Ruiz i Picasso—before her marriage, his mother was doña María Picasso i López and his father was don José Ruiz i Blasco. Around 1898, Pablo dropped his father's family name and signed his works Pablo Picasso. The first time we introduce a person in this book, we use the complete formal name, then afterwards we drop the "i" and the family name of the mother, except in cases where confusion might result.

On the walks, remember that there is far more to see than can be specifically pointed out in the book. The numbered sites direct you to locations of artistic and architectural interest, but the routes have sometimes been arranged to take you past monuments, museums, and other sites of more general interest. We have mentioned some of these in the text without numbering them separately, but even these do not represent all there is to see in this marvelous historic city. Be alert for many interesting sites along the way and, once you have completed the walks we suggest, you may want to investigate further on your own.

One final hint about the walks: you can either choose to take the walks in the morning, when the city is lively and active with sidewalks a bit crowded, or walk in the afternoon after two when most Catalans are at a leisurely lunch but before five when the sidewalks again fill with bustling activity. For a Sunday stroll, morning is an excellent time. Then, at three o'clock, every Barcelonan seems to appear as if by magic. On our first Sunday afternoon, we thought we were missing an important celebration but could not find a focus for the thousands of walkers and automobiles flooding the streets. It was just a normal Sunday afternoon in Barcelona.

WALK
ONE

THE
BOHEMIAN
BARRIO

CARRER DE WELLINGTON

MUSEU D' ART MODERN

PARLAMENT DE CATALUNYA

PASSEIG DE PUJADES

PASSEIG DE JOAQUIM RENART

24

25

PLACA D'ARMES

PLACA DE LA CIUTADELLA

ZOOLOGIC

PASSEIG CIRCUMVAL-LACIO

22 PASSEIG DE LLUIS COMPANYS

23

CARRER DEL COMERC

PASSEIG DE PICASSO

CARRER FUSINA

21

PLACA PONS I CLERCH

CARRER DEL COMERC

AVINGUDA MARQUES DE L'ARGENTERA

M

PLACA DE PALAU

M

CARRER DE LA PRINCESA

18 20

19

C. MONTCADA

C. CONSOLAT DE MAR

2

1

PASSEIG D'ISABEL II

C. REINA CRISTINA

3

4

C. LLAUDER

PLACA ANTONI MAURA

PLACA RAMON BERENGUER EL GRAN

C. ARGENTERIA

VIA LAIETANA

PLACA D'ANTONI LOPEZ

M

17

C. SOTS-TINENT NAVARRO

PASSEIG DE COLOM

PALAU DEL LLOCTINENT

C. LLEDO

C. FUSTERIA

CARRER DE LA MERCE

CARRER CIUTAT

16

PLACA SANT JAUME

15

PLACA SANT MIQUEL

PLATA

5

PTGE. DEL CREDIT

14

C. D'AVINYO

PLACA MERCE

C. DE FERRAN

13

CARRER DE CODOLS

6

7

PLACA DUC MEDINACELI

12

CARRER AMPLE

PLACA BOQUERIA

C. NOU DE SANT FRANCESC

LA RAMBLA

10 M 9

11

PLACA REIAL

LA RAMBLA

8

M

MONUMENT A COLOM

PLACA PORTAL DE LA PAU

N E S W

WALK ONE

Metro Barceloneta

The Barrio Gótico of Barcelona is typical of most ancient sections of European cities. Once known as the Cathedral Quarter, this area derives its name from its great Gothic buildings, which marked the height of the city and its culture during the Middle Ages. The narrow cobblestone streets that can seem mysterious—even frightening—in the dark of night are lined by low buildings set so close to the street that pedestrians and autos jostle for space. Only by entering through high wood doors or iron gates can a visitor see the bright interior patios around which daily living revolves. In the barrio, it is easy to imagine that you are in the Barcelona of medieval times.

As you exit the metro, turn right for three short blocks to Avinguda Marquès de l'Argentera. Turning left toward the bustling waterfront, walk for two blocks to the Plaça del Palau that straddles the divided Passeig d'Isabel II, cross the square to its far right corner, and turn left on Carrer Consolat de Mar. You will be in front of a large stone-columned structure that houses the Borsa de Barcelona, or stock exchange. The huge wooden entrance doors have a pair of handsome brass lion-shaped knockers. Continue to the carriage entrance and, if the exchange is open, here is where you enter.

1. Casa Llotja (Stock Exchange) Passeig d'Isabel II

The inner courtyard contains an interesting large fountain on the right. Across the court, above imposing large entrance doors, the name of the renowned art school formerly situated on the two top floors is still spelled out in metal letters. The Academia Provincial de Bellas Artes de la Llotja was located here when don José Ruiz i Blasco arrived in Barcelona from Málaga in October 1895 to begin his tenure as professor of fine arts. Picture the tall figure of Professor Ruiz, Pablo Picasso's father, dressed in a long overcoat and wearing a wide-brimmed felt hat on his head, walking from his nearby family home to teach his classes. Don José's greying mustache and reddish beard surrounded a straight nose, and his pleasant, sad eyes were submerged beneath heavy eyebrows. He was an academic painter of precise, realistic still-lifes; his only son would later state: "Father painted dining-room pictures, with partridges and pigeons, hares and rabbits.

Every hair and every feather."

Prior to arriving from the northern city of Corunya, the handsome, dark-eyed Pablo preferred his father's studio to school attendance and, under his father's guidance, the independent young artist worked for hours on end learning to sketch and paint in watercolors and oils. Of questionable authenticity is the story in which don José gave thirteen-year-old Pablo all of his paints and brushes with a vow never to paint again. By this action, the father was supposed to have acknowledged his young son's superior talent. After the move to Barcelona, Pablo was allowed to take the examination for entrance to the advanced class at La Llotja, although he was only fourteen and underage. During 1895–96, his extraordinary output of drawings and paintings recorded his discovery of the people and life in Barcelona but, as he later confessed to a friend in Paris, he did not like these early works and considered them inferior to those done under the sole tutelage of his father.

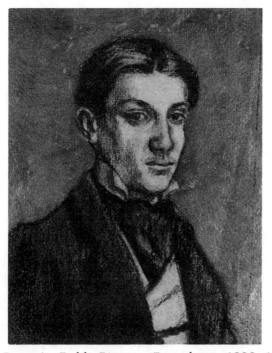

Self-Portrait, *Pablo Picasso, Barcelona, 1899–1900.* *(Museu Picasso, Barcelona)*

The Sala de Contrataciones (Maritime Stock Exchange), just to the left of the courtyard entrance, is worth visiting. In the impressive room, shares have been traded for over a century. The "well" where stock quotes are barked and bid is in the center of the room, surrounded by concentric-circling brass rails that descend into the well itself, now home to the modern computer. Notice the forty-five-foot walls paneled to the ceiling with dark wood, the massive wrought-iron-and-glass chandeliers, and the beamed ceiling with a surrounding wood catwalk reached from the third floor.

2. Apartment of Jaime Sabartés
Carrer Consolat de Mar

According to Picasso's long-haired poet friend Sabartés, in 1904 Picasso decorated the walls of Sabartés's apartment, in an unidentified old house on a corner of the narrowest part of this street, "in the spirit of Assyrian reliefs and of the pictures of the series 1901–1904." Pablo added this inscription to the completed images: "The hairs of my beard, although separated from me, are gods just as much as I." Sabartés, upon first meeting with Picasso in 1899, was "timid and surprised; admiringly and—because I had not the means to frequent cafés, theaters, music halls, and bullfights—with humility, I shook his hand for the first time." For the next five years, their lives were closely interwoven in Barcelona and Paris. In 1935, after thirty years' residence in South America, Sabartés joined the Picasso household staff in Paris and southern France to serve as intimate friend, secretary, and general factotum for the rest of his life. At the time of Sabartés's death in Paris in 1968, Picasso was living on the French Riviera but still held daily telephone visits with his cherished old friend.

Return to the Plaça del Palau and, with it on your left, cross the Passeig d'Isabel II. In doing so, note that at number 14 of the Porticos de Chifré is the old restaurant Siete Puertas (Seven Doors), founded in 1836, which is famous for its classic Catalan cuisine. The marathon lunches draw everyone from politicians to artists and, at the conclusion of this walk, it is an easy stroll to come back here for a meal in the classic ambiance. The porticoed building is an example of Barcelona's golden Gothic age in architecture. Continue toward the waterfront through the columned-porticoed arcades to the first street (it looks like an alley) on your right.

3. Apartment of the Ruiz family
Carrer Reina Cristina 3

This still lively old area bustled with the activity of arriving and departing ships, trains, mule carts, fishermen, and sailors when the Ruiz family arrived in 1895. In the midst of all of this, the narrow street, named for Queen Christina, was quiet and close to La Llotja for Professor Ruiz. It was not long before the Ruiz family, including Pablo and his younger sister Lola, moved from this small, dark apartment to nearby rooms that comprise the next site on this walk.

Turn right at the next corner.

4. Home of the Ruiz family
Carrer Llauder 4

Don José had left his fellow artist friends in Málaga and here he led a lonely schedule of walking to the nearby art school to lead his classes and then returning here to his family. In later years, Picasso described his depressed father's world as monotonous; he seemed to have only his work left. "No Málaga, no bulls, no friends, nothing." Like the rest of the family, Pablo did not know a word of Catalan; but unlike his reclusive father, the active young boy quickly learned to converse with his classmates, jumping into the spirit of Catalunya that would leave a profound and lasting influence on him. American writer Gertrude Stein, Picasso's friend in Paris for forty-two years, said that Picasso had the Spanish temperament of sadness—*duende* (soul or dark spirit)—and "had in him not only all Spanish painting but Spanish cubism which is the daily life of Spain." Even today, artists claim that the light in Barcelona is different—that it is brighter and that this affects the colors in their paintings.

Cross the Passeig d'Isabel II and cut through the Plaça d'Antoni López, turning left to cross Via Laietana and pass the rococo postal telegraph building to where Carrer de la Mercè begins. Walk this street for two blocks and take a left at Carrer Plata to the middle of this short block.

5. Studio of Pablo Picasso
Carrer Plata 4

At the beginning of summer 1896, Picasso's father rented a studio close to the family home so the young precocious artist could be independent. Pablo was not so liberated,

however, that the proud father did not stop by every day to check on his progress. For his son's first important work, painted here, Don José sat as the model for the figure of a doctor sitting by the bedside of his patient in the huge canvas, *Science and Charity.* Later, Picasso claimed that all the men in his works are images of his father. This work by the fifteen-year-old artist won an honorable mention in the National Exhibition of Fine Arts in Madrid and later a gold medal in Málaga. The large painting was of great significance to Picasso; it was his first major work and his first success. Toward the end of 1898, he stopped signing his work Pablo Ruiz i Picasso, instead adopting only his mother's maiden name. As he recounted to photographer Brassï in 1943, "I'm sure (what attracted me to it) was the double *s,* which is very rare in Spain. . . . Can you imagine me being called Ruiz? Pablo Ruiz? . . . Have you ever noticed there's a double *s* in Matisse, in Poussin, in Rousseau?"

In his book *A Life of Picasso,* Richardson wrote that from the time Picasso was a child he had what his fellow Andalusians call *la mirada fuerte* —"strong gazing"— a shamanistic ability to possess something through intense observation. Witnesses claimed that Picasso could look right through one. Picasso's portraits show a face dominated by huge, coal-black eyes that appear to stare directly at the observer.

Return past Carrer de la Mercè to Carrer Ample, turn left, go down to Carrer de Còdols, and turn right for a stroll of about fifty yards to number 16 on your left.

6. Design of Antoni Gaudí i Cornet
Carrer de Còdols 16

This narrow street of ancient buildings appears so unchanged by the past four centuries that it gives us a feeling of medieval daily life in the old barrio. But like the rest of Barcelona, it is peppered throughout with the fantasy-like Moderniste buildings characteristic of the work of Gaudí and his assistants and colleagues. The twentieth-century Catalan surrealist artist Salvador Dalí considered Gaudí to be the last great architectural genius. According to Dalí, the Catalan name Gaudí translates to "enjoy" and Dalí means "desire"; and enjoyment and desire are attributes of Mediterranean Catholicism and Gothic art, which were reinvented and

brought to a state of paroxysm by Gaudí. He designed laundry facilities, in 1897, on the roof of this structure owned by his primary patron Count Eusebio Güell. It was typical of Gaudí's work that he never shied from giving artistic architectural expression to even the most practical aspects of his acutely designed buildings.

Gaudí was born on 25 June 1852 in the city of Reus, just inland from Tarragona, and his coppersmith father, Francesc Gaudí i Serra, worked a farm in nearby Rindoms. In 1873, after ten years of study at a religious school in Reus and with the science faculty of Barcelona University, where he excelled in mathematics, Antoni enrolled in the newly established Escuela Provincial de Architecture de Barcelona. While still a student, Gaudí had already begun the career that would spark a whole movement, a catharsis, in modern architecture. Like his American architectural contemporary Frank Lloyd Wright, Gaudí considered the surrounding environment and functional purpose of his designs, but his fanciful solutions were dramatically his own. The Modernisme movement in architecture took place initially and primarily in Catalunya, where Gaudí's works are mostly located. After he received his architectural degree in 1878, it was only during the first phase of his career, from the years 1880 to 1900, that he worked on any commissions outside of the region around Barcelona.

It is probable that the older Gaudí had little effect on Picasso. When questioned about Gaudí, the artist answered: "I was not impressed. Gaudí did not impress me at all." Then, as an afterthought: "In fact, maybe just the opposite."

Backtrack on Carrer de Còdols, cross the Plaça Mercè, and turn right on Carrer de la Mercè.

7. Home of the Ruiz family
Carrer de la Mercè 3

Senyor and Senyora Ruiz and Lola moved to the first floor of this building, which has just been completely renovated, at the same time that Pablo, at fifteen, was set up in his own studio. He was not entirely independent from the family, as he continued to sleep and eat most of his meals here. Manuel Pallarés, who also attended and studied art at La Llotja, eighty years later said of the young Picasso: "In everything, he was different. . . . At fifteen, he neither seemed nor acted like a

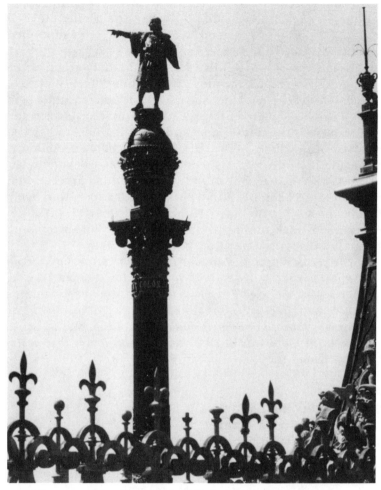

Monument to Christopher Columbus. (Courtesy
Oficina Tècnica d'Imatge, Ajuntament de Barcelona)

boy his age. He was very mature."

Cross the small palm-studded Plaça Duc de Medinaceli
(a good people-watching spot) to the corner nearest the sea,
and from there take the Passeig de Colom right for three
blocks to the Plaça Portal de la Pau to view the Monument a
Colom *standing in this great esplanade.*

The monument was begun in 1882 but was not com-
pleted until 1888, when it was inaugurated along with the

first Universal Exhibition. The lofty statue of Christopher Columbus presides over the port of the Spain ruled by their Catholic Majesties Ferdinand V and Isabel I, who supported his first voyage to the Americas in 1492.

In the year 1992, the five hundredth anniversary of the voyage of Columbus, Spanish artist Antoni Mirala will have cemented the close relationship between America and Spain with a symbolic marriage between the Statue of Liberty and the statue of Columbus. Since the gigantic bride and groom are staying in their permanent locations, the ceremony is scheduled to occur on a street in Las Vegas for, in Mirala's words, Las Vegas is "one of the best cathedrals in the world, with all those neon lights and parking." The reception being planned is a parade down Fifth Avenue in New York City featuring a truck trailing a Just Married sign and a hundred thousand clanging Coca-Cola cans.

The six contiguous Ramblas begin here with the Rambla de Santa Mónica. Turn right onto it and head away from the sea. As you stroll, one Rambla gives way to another, and the street signs reflect the changes of names. Walking with the gregarious late-night crowds on Las Ramblas makes it easy to understand the words of Lord Byron: "Oh, lovely Spain! Renowned romantic land!"

8. Gaudí street lamps
Rambla de Santa Mónica

Gaudí's first and only municipal commission for the city was for street lamps on the lower Ramblas and their companions in the Plaça Reial. Gaudí received the municipal appointment as a result of a lengthy memorandum, dated June 1878, concerning the "urbanistic importance of street lights." Along the Rambla de Santa Mónica, in the Plaça del Teatre across from the statue of Frederick Soler, the founder of the Teatro Català and the Teatro Principal, are fine examples of six-limbed lamp posts. The delicate detail and elaborate design on these lamps represent part of the beginning of the unusual ornate designs associated with the work of Gaudí. Commenting on his role as an architect, he once stated: "The architect must not speak in vague terms. Like the ornamentalist, but more concretely, his language is geometry."

Casa Antigua Figuroa. (Courtesy Oficina Tècnica d'Imatge, Ajuntament de Barcelona)

9. Casa Antigua Figuroa
Rambla de Santa Mónica, Carrer Petxina

This neo-Gothic–style building with a highly decorated exterior of shiny glazed tiles was constructed in 1852. The fanciful façade is typical of pharmacies and shops of the middle of the nineteenth century, when Catalan intellectuals began a cultural campaign to revive the Catalan language, literature, and arts and crafts, including ceramics and tiles. The window display of pastries will make it difficult for you to stay outside.

A visit to the Mercat Sant Josep, also known as the Mercat la Boquería, just across Carrer Petxina, will provide *mucho ambiante*. Over 150 years old, the building is a fine example of ironwork architecture with ornamental façades.

10. Museu de Artes Decorativas
(Decorative Arts Museum)
Rambla Santa Mónica 99

Hours: 10 A.M. to 2 P.M. and 4:30 P.M. to 9 P.M., except holidays, when it is open only in the morning.

To your left as you enter the neoclassical structure is the office of the Friends of Museums of Catalunya. An information office and library is on your right.

The museum occupies the second floor of the Palau de la Virreina, or Palace of the Vicereine. Between 1772 and 1777 Manuel Amat, the viceroy of Peru, sent detailed plans from Lima for the construction of this palace by architect and sculptor Charles Grau (1717–1798). Soon after its completion, the viceroy died and his widow, the vicereine, lived in the baroque mansion. The reception room is impressive with its twin staircases, as is the rococo dining room. The museum contains a variety of decorative art collections, including exceptional sixteenth-century Catalan glass, Alcora porcelain, washbasins, watches, gold, silver, and sixteenth- to nineteenth-century furniture.

The building next door was restored in 1990. It is an 1850 home built for Francesc Pina, and the architect was Josep Fontserè i Domènech.

Cross Las Ramblas and, heading back toward the sea, walk down the center to the Carrer Colom, a small street that comes in from your left. Take it to its end, just a few steps away.

11. Design of Gaudí
Plaça Reial

Other than his student work for architect Josep Fontserè i Mestres (1829–1927) in the Parc de la Ciutadella, the two lamp posts that beautify and illuminate this rather gloomy palm-studded plaza are thought to be the original public examples of Gaudí's post-Gothic designs. Look for the heraldic shield of the city of Barcelona at the bases of the posts. The tops are crowned with the winged helmet of Mercury, symbolic of Barcelona's historic maritime and continuing commercial interests. The six branching arms were originally intended to be painted the Catalan red with gold fluting. They hold opaque white shades capped with midnight-blue glass domes. The dark and serious tone of the lights seems to fit

well with the classically columned plaza, a favorite of Miró's. Not only did he admire the lamps and shaded arcades, but he declared the palm tree to be the natural primary example of Catalan Gothic style.

Exit onto Carrer Tres Llits, on the opposite side of the square, and proceed to the next street and the unmarked painted door on your right.

12. Studio of Picasso
Carrer Escudellers Blancs 1

Because he was always poor, Picasso shared a variety of dreary studio rooms with other young artists. In 1899, this old house contained a small studio Picasso shared with the painter Santiago Cardona i Turró and his sculptor brother Josep, who had both been Picasso's classmates at La Llotja. The tiny room quickly became a social center for Picasso's crowd. Through the main door of the mezzanine floor, a short corridor to the left led off a small hall. On the left of the corridor was the room where Pablo daily sketched and frantically painted instead of returning to classes at La Llotja as his father wished. In his free time the young artist amused himself by punching eyelets in corsets on a machine in a corset shop located here and managed by the mother of the Cardona brothers. Forty years later, Sabartés described his feelings on his initial visit to this studio: "My eyes were still dazzled by what they had seen among his papers and sketchbooks. . . . On passing before him to go, I implied a kind of obeisance, stunned as I was by his magic power, the marvelous power of a Magi offering gifts so rich in surprises and hope." The close warm friendship that followed lasted for the rest of Sabartés's life.

Carrer Lleona begins here. Continue on it to the next intersecting street.

13. Inspiration for Picasso's painting
Carrer d'Avinyo

Picasso's landmark eight-foot-square painting *Les Demoiselles d'Avignon* was titled by the French surrealist author André Salmon because of the portrayed women's resemblance to the nudes in a brothel formerly located somewhere on this street, where Picasso frequently bought his watercolors and paper. "It was called the *Avignon Brothel* at first,"

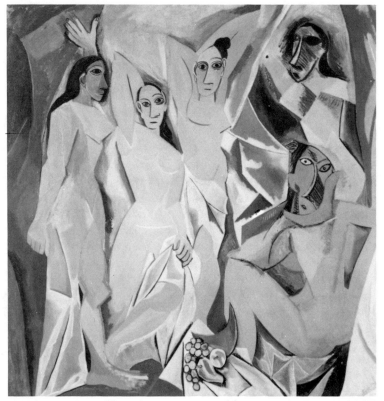

Les Demoiselles d'Avignon, *Pablo Picasso, Paris, 1907.*
(Museum of Modern Art, New York)

stated the painter, "because Avignon was a name I had
always known, linked to my life. I lived just off the Carrer
d'Avinyo. . . . Today they call it the *Demoiselles
d'Avignon*. How that name irritates me!" Five female
nudes, posed in front of a deep blue curtain, stare at the
viewer through exaggerated black wide-open eyes. This
stark painting done by Picasso in Paris in 1907 shocked
his friends, one of whom commented, "What a loss to
French art!" The picture not only marked a complete
departure from his previous rose period, but it also be-
came a transition to the cubist revolution of Georges
Braque and Picasso, thus heralding the commencement
of a new era in the arts. Eventually, Picasso's fellow
artists, writers, and critics acclaimed his genius, except

for Gertrude Stein's brother Leo Stein, who condemned cubism as "godalmighty rubbish!" Wrote Gertrude:

Cubism is a part of the daily life in Spain, it is in Spanish architecture. The architecture of other countries always follows the line of the landscape, it is true of Italian architecture and of French architecture, but Spanish architecture always cuts the lines of the landscape and it is that that is the basis of cubism and that is what Spanish cubism is.

Picasso did not exhibit the painting until the 1916 Salon d'Antin in Paris, when Salmon gave it this title. After it was shown in 1923 in New York, the Museum of Modern Art acquired it after selling a Degas equestrian picture for eighteen thousand dollars to raise the twenty-four-thousand-dollar total purchase price.

Cross the street to where Carrer Lleona becomes the Boulevardia Sant Miquel and on your left search for large red metal gates opening into the short Passatge del Crèdit. About three-quarters of the way in, on your left, are two wall plaques placed on either side of a door.

14. Birthplace of Joan Miró
Passatge del Crèdit 4

On 20 April 1893, the modern Catalan painter was born in this dark, unattractive nineteenth-century house. Twelve years after Picasso, Miró, a younger cousin of Sabartés, also studied at the nearby art school, although his prosperous goldsmith father forced him to attend a school of commerce for three years also. Then, again to satisfy his strict father, he spent a year as a clerk in a business. After a severe illness, in 1911 Miró was sent to recuperate on a farm near Montroig (Red Mountain), just south of Tarragona, in the country of his father's ancestors. Miró had admired Gaudí, who was born nearby, since childhood. This enjoyable time in the country would later translate into his paintings of farm scenes; the most celebrated was purchased in Paris in 1922 by Ernest Hemingway for his first wife, Hadley. Upon his return to Barcelona, he did not return to La Llotja because he had become dissatisfied with the school's traditional teaching methods. Instead, he enrolled in an unconventional art school headed by Francesc Gali, who taught him to draw an object by developing his sense of touch so acutely that he

never had to see the article. Later, in 1915, Miró attended classes at the Catholic Sant Lluch Circle, which owed its reputation partly to the fervently religious former student Gaudí, whose use of unusual shapes and materials greatly influenced the work of Miró. A small low-roofed room on an upper floor of this house served as Miró's first studio. Even though he kept other studios in Barcelona and lived in Paris for roughly twenty-five years, Miró kept the family house and his studio here until 1956. He had returned from Paris in 1942 and lived here with his mother, who died in 1944. Then, in 1955, he commissioned the post-modernist architect Josep Lluís Sert to design his final studio in Palma, the capital city of his mother's native Mallorca. The two Catalans had collaborated previously when the Spanish Republican government commissioned Sert to design the Spanish pavilion for the 1937 World's Fair in Paris and Miró to paint a mural for it. When the pavilion was inaugurated in July, it contained Picasso's completed *Guernica,* along with his *Woman with Vase.* One of his sculptured heads of a woman was placed near the exit stairs.

Continue through the passatge and turn right on Carrer de Ferran to reach Plaça Sant Jaume.

15. Plaça Sant Jaume, Casa de la Ciutat-Ajuntament (City Hall)

Enter the neoclassical façade of this building that has been constantly undergoing alteration since its initial construction in the fourteenth century. The central portion of the main floor is occupied by the Sala de Ciento, the meeting chamber of the Council of a Hundred Jurors. It was built in three well-differentiated stages: the Gothic work between 1369 and 1407; the Baroque portions dating from 1628 to 1684; and the modern renovations begun in 1848 and completed in 1929. Around 1888, Lluís Domènech i Montaner was involved in the transformation. The decoration you see in the hall was completed in 1925. The only large chair in the Sala de las Reina Regente was designed by Gaudí.

Opposite the grand interior patio is the stone staircase built in 1929 with the early coat of arms of the city carved on the pillars of its banisters. Murals by Miguel Viladrich decorate the walls between floors. At the head of the stairs is Josep Viladomat's sculpture *Maternidad* (Motherhood). Visit

the Sala de las Cronicas (Room of the Chronicles) to see the black marble decorations by the Catalan muralist Josep Maria Sert (1874–1945).

Across the plaza is the Palau de la Generalitat, the center of the autonomous Catalan government. The main Greco-styled façade is centered by an equestrian statue of St. George by the sculptor Aleu.

Continue through the plaza, and on your right at the end of the City Hall is Carrer Ciutat. Turn right and follow this street past Carrer Templaris to the Plaça Regomir where it becomes Carrer del Regomir.

16. Studio of Miró
Carrer del Regomir

Before Miró could finally see the Paris that excited the older Catalan artists, he worked in a studio located some-where on this street and waited for the First World War in Europe to end. He attended an exhibition of French con-temporary painting and, in 1917, he saw a performance of the Ballets Russes in Barcelona's opera house. At his first public show, in 1918, his paintings were poorly accepted by the public. That same year he met the unconventional dada artist Francis Picabia. All of these events strongly convinced him that his development as an artist lay in the liberal milieu of Paris, where unorthodox artists and writers found accep-tance.

When an excited Miró arrived in Paris in late 1918, the older Picasso found him a simple hotel room in an area inhab-ited by other poor Spanish artists and purchased two of Miró's paintings, including a self-portrait that he treasured all of his life. Even though Picasso treated the lonely Spaniard as a brother, the quiet introverted Miró was unbearably homesick and spent hours roaming the unfamiliar streets of Paris, un-able to create a single image on a canvas. After four or five months he returned to Barcelona, but he soon realized he would not continue to grow as an artist without the stimula-tion of the other painters gathered together in Paris. He sold the complete collection of his work for enough money to live on for a year and returned to France in 1921 to a studio lent him by the Spanish sculptor Pau Gargallo. Although always on the edge of starvation, Miró found consolation in the plethora of museums and the appreciation and encourage-

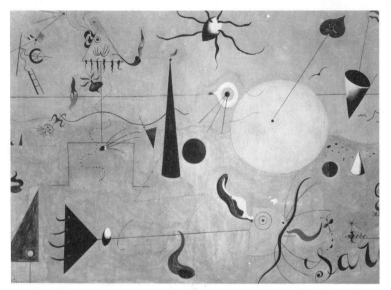

Catalan Landscape (The Hunter), *Joan Miró, Paris,
1923–24. (Museum of Modern Art, New York)*

ment he received from his neighbors, the rue Blomet group
of dadaists that included André Masson and Picabia. Now the
shy Catalan artist exclaimed, "Never again Barcelona, that's
flat. Paris—to the day I die."

Miró's surrealist paintings are done in brilliant bold col-
ors with free forms or geometric lines. The 1923–24 surrealist
work *Catalan Landscape (The Hunter)* is an example of his
inventive use of symbols for language and his sense of hu-
mor. In the lower right corner he painted the first four letters
of the name of the traditional Catalan folk dance, the sardana.

*Double back up the Carrer Ciutat toward the Plaça Sant
Jaume to the last street that comes in on your right before the
plaça, the Carrer d'Hercules. Turn right and walk through the
historic Plaça Sant Just and down the small Carrer Bisbe
Caçador.*

17. Galeria de Catalans Il-lustres
Carrer Bisbe Caçador 3, Reial Acadèmia de les Bones Lletres

Hours: 11 A.M. to 2 P.M. and 5 to 8 P.M. Admission is free.

At the end of the dark medieval street with an authentic
feeling of old Barcelona, the cobblestoned front patio and

unrestored building can appear forbidding. This is now the headquarters of the Academy of Fine Literature and houses the gallery of illustrious Catalans. The gallery was created in 1840 and contains portraits of forty-seven distinguished Catalans who lived between the tenth and twentieth centuries.

Walk around outside the ancient palace on Carrer de Lledó and Boulevardia Caçador to the Plaça Emili Vilanova and, after a left turn onto Carrer del Sots-Tinent Navarro, you will see the remains of the ancient Roman and medieval walls that once enclosed the Gothic town. At Carrer Jaume I, turn left for a block then right on Carrer Trompetes de Jaume I that becomes Carrer Veguer.

On the right is the Palau Reial Major, or Main Royal Palace, on the Plaça del Rei. Now the museum of the city, this was formerly the residence of the counts of Barcelona. Inside, in the Tinell Room, King Ferdinand V and Queen Isabel I received Columbus at court upon his return in 1493 from his first voyage to the Americas. Washington Irving wrote in *Life and Voyages of Columbus:* "As Columbus approached, the sovereigns rose, as if receiving a person of the highest rank. Bending his knees, he requested to kiss their hands; but there was some hesitation on the part of their majesties to permit this act of vassalage. Raising him in the most gracious manner, they ordered him to seat himself in their presence; a rare honour in this proud and punctilious court." In the Plaça Ramon Berenguer el Gran is a bronze statue of Berenguer the Great atop his horse by sculptor Josep Llimona. Berenguer is given credit for turning the County of Barcelona into a western Mediterranean power.

Back track to Carrer Jaume I and turn left to cross busy Via Laietana, and you will be on Carrer de la Princesa. After about three blocks turn right on Carrer Montcada.

18. Museu Picasso
Carrer de Montcada 15–17, Palau Berenguer d'Aguilar

Hours: 10 A.M. to 2 P.M. and 4 to 8 P.M. (last tickets sold at 7:30 P.M.) Free on Sunday.

This narrow street was the center of Barcelonan society from the fourteenth to the eighteenth centuries. The palaces of nobles and merchants were built here, with central en-

trances leading to courtyards containing open staircases climbing to the first floor. In 1947, the entire length of the street was declared a historical landmark.

The Picasso museum, located about midway down the street on its left-hand side, occupies adjoining fourteenth- and fifteenth-century former palaces and is entered through the cobblestoned, plant-filled patio at number 15. It contains hundreds of the early works executed by Picasso between 1896 and the beginning of the Spanish civil war in 1937. In 1968 Picasso donated his series *Las Meninas* in memory of his friend Sabartés, who had died that year and who, in 1952, had donated all of the works by Picasso that he owned to the city of Barcelona. These are all now part of the museum's permanent collection. On the twentieth anniversary of the museum, a plaque was placed on the wall at the rear of the patio, "In memory of Pablo Picasso and Jaime Sabartés 1963–1983." The adjoining palace at number 17 was acquired in 1970 to hold the Ruiz family memorabilia acquired from the estate of Picasso's sister, Lola Ruiz Picasso de Vilató. This collection of Picasso's early works consists of eighty-two oils on canvas and twenty-one on other bases; six hundred eighty-one drawings, pastels, or watercolors on paper; seventeen notebooks or sketch pads; four books with drawings in the margins; and five assorted objects. No project of Picasso's done before the age of nine is included. He is supposed to have claimed that he never drew like a child, but some critics feel he destroyed all his efforts before this age so that this boast could never be invalidated.

From 1904, when Picasso settled permanently in France, until 1937, he made frequent visits to his beloved Spain. After the bombing of the peaceful Basque city of Guernica on 26 April 1937, he vowed never to return to Spain and considered himself an exiled Spaniard until his death in southern France on 8 April 1973 at the age of 92. When invited to attend the opening of the new wing of the museum, Picasso replied, "You can't invite a Spaniard to come to Spain." He was adamant that he would never return as long as the dictator Franco ruled. Although Picasso remained a resident of France for seventy years, Spain was always in his memory and heart, so he generously continued to send his works to this museum.

Picasso changed modern art. The kind of painting practiced by artists before him was revolutionized after the

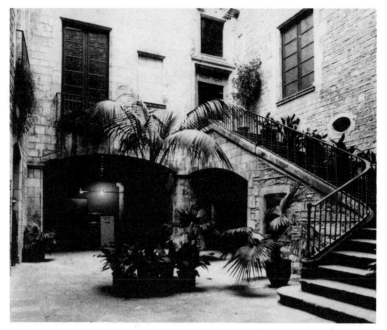

Interior courtyard, Museu Picasso. (Courtesy Oficina Tècnica d'Imatge, Ajuntament de Barcelona)

Catalan genius's intervention in the world of plastic arts. As Picasso said of himself: "We now know that art is not truth. Art is a lie that makes us realise truth, at least the truth which is given us to understand. . . . The artist must find the way of convincing the public of the entire veracity of his lies." Picasso's artistic adventures followed this orientation throughout his different periods, styles, and media. The tremendous influence of Picasso's last wife, Jacqueline Roque, on his work from 1954 to 1971 was celebrated with a special exhibit, "De Picasso à Jacqueline" (From Picasso to Jacqueline) from October 1990 to January 1991. One hundred forty works in diverse media in which Jacqueline appears were collected from museums in New York, Germany, Paris, Detroit, and Vienna, as well as from his granddaughter, to accompany those already in the permanent collection of the Picasso Museum. Before her suicide in 1986, Senyora Picasso was always a friend to Barcelona and a generous patron of this museum.

Across the narrow street at numbers 12–14 in Gothic

buildings begun in the thirteenth century, the Marquès de Llió and Nadal palaces today contain the Museu Tèxtil i de la Indumentària (Textile and Clothing Museum).

19. Home of Ramón Pichot i Gironés
Carrer de Montcada 21

This neighboring mansion was the family home of the painter Pichot (1870–1925), a lifelong friend of Picasso. Although they inhabited a large house on a street populated by wealthy landowners, the Pichot family of four sons and two daughters lived a bohemian life in which music, poetry, and painting were important. Pichot was a member of the group of young revolutionaries gathered at the café Els Quatre Gats (Walk 2, #15) and he eventually joined many of them on Montmartre in Paris. Picasso's sadness upon hearing of his dear friend's death in 1925 is reflected in his drawing *Dance,* in which the ritual of the dance becomes a kind of strange funeral ceremony.

Salvador Dalí, a close friend of the Pichot family, joined them in the small fishing village of Port Alguer, where he settled into a studio on Riba Pichot.

20. Gallery Maeght
Carrer de Montcada 25, Palau de Cervello

This former palace dates from the fifteenth century, with additions and renovations in the sixteenth and eighteenth centuries, and now houses the Barcelona branch of the gallery. Look for the catalog of wood engravings and etchings that includes works by Braque, Miró, and Picasso. The Maeght Foundation (Museum of Contemporary Art), beautifully situated in St. Paul de Vence in southern France above the côte d'Azur, was designed by Catalan architect Josep Lluís Sert (1902–1983).

Reverse your course on the Carrer de Montcada and turn right on Carrer de la Princesa; continue for about one and a half blocks to Carrer del Comerç at the Plaça Pons i Clerch and turn right again.

21. Studio of Picasso
Carrer del Comerç 28

Before his final return to Paris in 1904, the twenty-three-year-old Picasso could finally afford a studio by himself. By this time he had crossed the Pyrenees eight times in search

of an environment conducive to both a balanced life and stimulation for his work. He was still painting the somber blue-period works when he found this studio close to the two attic rooms inhabited by Sabartés and just opposite the studio of Nonell. Picasso, still restless, decided in April to leave Barcelona for the last time, except for holidays and short family visits. He had returned to Barcelona fourteen months previously to—as he wrote to his friend the French poet, Max Jacob—"do something." During this time he produced a great quantity of the most memorable and typically gloomy work of his blue period. Accompanied by Sabastià Junyer i Vidal (1874–1945), a painter of conservative landscapes and outdoor scenes, Picasso now planned to settle in the bohemian section of Paris "not to conquer Paris," wrote Maurice Raynal, "but to find a cure for life." It was during this year of 1904 that Picasso, under the direction of Ricardo Canals i Llambí (1876–1931), produced the fine etching *The Frugal Repast*. Bernhard Geiser, the authority on Picasso's graphic work, stated that under the guidance of Canals "Picasso became accomplished enough in the techniques of etching to be able to get the effects he wanted." Only in Paris—the scene of new ideas in art, literature, and music, mixed with the history of French painting—could Picasso exploit his heritage of Spanish temperament and intellect.

Continue straight ahead for approximately one block, then turn left onto Carrer Fusina, which will dead-end into the Parc de la Ciutadella. The Romanesque arcaded buildings facing the park were constructed in 1836. Cross the Passeig de Picasso, a boulevard created from a tawdry street, then turn right and go for about half a block.

In front of the ornate iron fence, designed by Gaudí while still a student, is the Antoni Tàpies sculpture *Homage to Picasso*. Inside this large glass cube with water pouring down its sides are random pieces of Picasso's furniture and canvas, alluding to his nonconformity.

Retrace your steps and continue on to cross the Passeig de Pujades, turn right to reach the Passeig de Lluís Companys, and then turn left to walk to the far end of this parklike way.

22. Arc del Triomf designed by Josep Vilaseca i Casanovas Passeig de Lluís Companys

This enormous brick arch was erected for the wildly popular 1888 Barcelona Universal Exposition. Brick was

chosen by Josep Vilaseca (1843–1910) and his collaborators to affirm the Spanish character of the exposition and to integrate it with the other major pavilions and structures erected primarily for the exhibition. Double-crowned cupolas top each side of two supporting pillars that, in tandem with the brick façade and classic figures bordering over the arch itself, make the structure a blend of both Romanesque and Spanish architectural styles. The detailing on the face of the arch attests to Vilaseca's fascination with oriental culture and design. Although not considered a true pioneer like Gaudí, Vilaseca was highly representative of the new Catalan creativity. Cultivated, well-traveled, and elegant, in his work he revealed the influence of Egyptian art and architecture popularized because of the colonial French military campaigns of the early part of the nineteenth century in the Middle East.

Walk back along the passeig and enter the Parc de la Ciutadella (city park). On your right will be the Museu de Zoologia and to your left the path to the Cascada i Llac Artificial.

The former ciutadella (fortification) built for Philip V was to become a symbol of absolutist oppression when the revolutionary junta gained power in the insurrection of 1868. From 1875 to 1881, Fontserè designed and supervised the construction of a city park on the land. In an attempt to recover from Catalunya's severe economic recession of 1886, the Universal Exposition of 1888 was held. Gold fever in 1881–83 coinciding with expansive railway development and the Catalan wool industry (the largest in Europe, linked with the cotton trade from Cuba) all contributed to boom years for the economy of Barcelona. Initially, the fair was conceived during these good years, but with the collapse of the economy in 1886 it was continued as a means of smothering the shock of a temporary crisis. The exposition came in time to mark a new phase in the modernization of the social, professional, and political arenas in Barcelona. An astounding four hundred thousand visitors from many countries throughout the world visited the twelve thousand "stands," or displays of economic goods and wares by commercial interests. The highly successful event allowed the city to place itself once again prominently on the map of Europe.

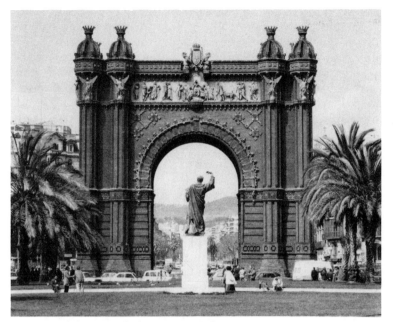

Arc del Triomf. (Courtesy Oficina Tècnica d'Imatge, Ajuntament de Barcelona)

23. Museu de Zoologia (Zoological Museum) designed by Domènech
Parc de la Ciutadella

Erected in just sixty-three days, in 1887–88, this building was originally designed by Domènech to hold the café-restaurant Castell dels Tres Dragons. Despite the rapid pace of construction, it still was not quite ready for the official opening. Simultaneously, Domènech built the nearby International Hotel which, unfortunately, was demolished at the close of the exposition. The ground on which the five-hundred-foot café-restaurant was planned was of such poor quality that Domènech designed an ingenious system of foundations, with a recyclable grid of railway tracks, upon which he stretched a series of chambered countervaults. Making use of the quickly evolving possibilities of modern machinery and materials to produce an original and structurally sound building was a prime characteristic of the work of Domènech and his innovative Catalan colleagues.

The façade of ordinary red brick is geometrically

patterned to create a blend of Moorish, Egyptian, and Spanish images. Because the building was never completed, it was fortunately spared the continuing ornamentation planned for the exterior, allowing it to retain its bold clear impression. It is a significant building—perhaps one of the most important works of its time in Europe—because of its strong blend of the past with Moderniste influences, the quality of the building materials, and the type of construction that used new methods made possible by recently invented machinery. Exposed iron was not only used for the roof arches, but even in the façade lintels—a remarkable design for the turn of the century. This was very likely the first work in which the geometric plane was regarded as a fundamental element in architecture; both the sculptural and structural senses of the plane in this edifice are autonomous. At the close of the fair in 1888, the restaurant building was converted into a workshop to try to recover the traditional Catalan arts—smelting, woodcarving, and glazed ceramics—with help from a large number of craftsmen. Catalan Gothic style influenced Domènech, and this work ushered in an era of architectural

Artificial lake and falls, Parc de la Ciutadella. (Courtesy Oficina Tècnica d'Imatge, Ajuntament de Barcelona)

rationalism that in a short time was revealed most magnificently in his masterpiece, the Palau de la Música Catalana (Walk 2, #14).

Now cross the park along its north side, bordered by Passeig de Pujades, toward the Cascada i Llac Artificial. You will undoubtedly notice the many families of cats of varying ages, shapes, and colors lounging in the sun on the benches or lying in the bushes. The park appears to be a feline hostel.

24. Designs by Gaudí
Cascada i Llac Artificial (Artificial Lake and Waterfall)

Gaudí was a student at the time the park was built, and evidence of his contributions and influence in the fountains, rails, and other park details continues to be discovered. An existing photograph shows Gaudí, around 1877, at work at the Eudaldo Punti ironworks that were responsible for casting the park's fence. The sculptures on the huge ornate fountain are signed by the respected sculptors of the day: Nobas, Gamot, and Fotaqts Fluxa. The four nearly identical winged dragons on the front are unsigned and could be early works of Gaudí. The same is true of two roundels featuring lizards, or salamanders, on the back wall of the upper terrace. Relatively recent information reveals that Gaudí's signature can be found hidden on the back of some of the less notable figures on the fountain. The reservoir that holds water for one of the major fountains was a school project of Gaudí's; the project and calculations were accepted in place of a formal written examination.

Walk to the center of the park and south through the gardens toward the sea. Then turn left through the Plaça d'Armes to a building with two extending wings. The one on your right houses the Catalan parliament. You want to enter the one on the left.

25. Museu d'Art Modern (Modern Art Museum)
Palau de la Ciudadella

Hours: 10 A.M. to 7 P.M. Tuesday to Friday; Sunday 10:30 A.M. to 4:30 P.M. Closed on Monday.

In 1875–81, Fontserè designed the reconstruction of the original structure, built in the eighteenth century as part of the city's arsenal and then later remodeled into a royal resi-

dence. At the beginning of the twentieth century the building was again remodeled to exhibit paintings, sculptures, drawings, engravings, and decorative arts mainly by Catalan artists of the late nineteenth and early twentieth centuries. Included in the collection are two portraits by Santiago Rusiñol of art historian and critic Miguel Utrillo i Morlius (1862–1934), noted for allowing French artist Suzanne Valadon to give her son Maurice his good family name. The Catalan group in Paris during this era whose works are on display include Utrillo, Rusiñol, Pere Romeu, Ramón Casas, Joaquim Mir, Isidro Nonell, Joaquim Sunyer, Ricardo Canals, Salvador Dalí, Joan Miró, and J. M. Sert.

Upon leaving the museum, head straight southwest through the park and out the entrance gates designed by Gaudí. Pass through them onto Avinguda Marquès de L'Argentera, and you will be headed back to the Barceloneta Metro—or, if you wish, toward the restaurant Siete Puertas for a memorable lunch.

WALK

RAMBLING

L A S

RAMBLAS

TWO

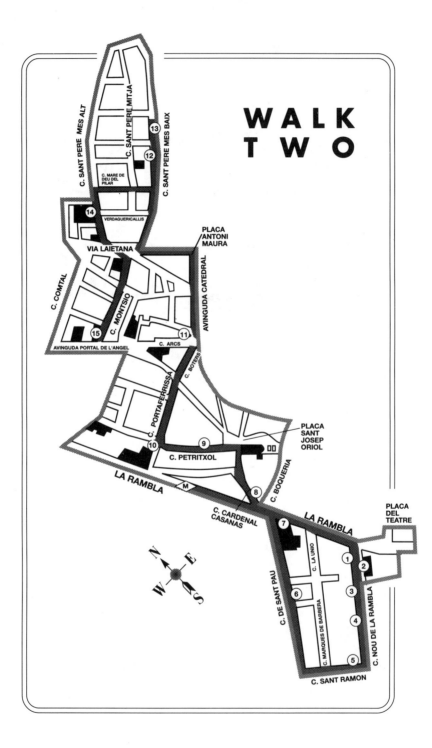

WALK
TWO

C. SANT PERE MES ALT

C. SANT PERE MITJA

13

12

C. SANT PERE MES BAIX

C. MARE DE
DEU DEL
PILAR

14

VERDAGUERICALLIS

PLACA
ANTONI
MAURA

VIA LAIETANA

C. COMTAL

C. MONTSIO

AVINGUDA CATEDRAL

15

11

AVINGUDA PORTAL DE L'ANGEL

C. ARCS

C. BOTERS

C. PORTAFERRISSA

10

9

PLACA
SANT
JOSEP
ORIOL

C. PETRITXOL

C. BOQUERIA

LA RAMBLA

M

8

C. CARDENAL
CASANAS

LA RAMBLA

PLACA
DEL
TEATRE

7

C. DE SANT PAU

C. LA UNIO

1

2

6

3

C. MARQUES DE BARBERA

4

C. NOU DE LA RAMBLA

5

C. SANT RAMON

N
W E
S

Metro Liceu

For over a hundred years, Las Ramblas have been the heart of Barcelona. The contiguous streets that run from the Plaça Portal de la Pau to the Plaça de Catalunya are centered by a very broad tree-shaded sidewalk. Appearing unchanged today, the exciting promenade is lined with flower sellers, stands selling newspapers and magazines from throughout the world, or shrieking birds and animal pets. The crowded, cosmopolitan, colorful ribbon of joined streets is alive day and night with people, including couples "dar el paseo" (courting), with arms entwined while rambling up and down or sitting at the numerous tables set on the pavement. If this were the late nineteenth century perhaps we would see good friends Gaudí, Count Güell, and painter Alejo Clapés deep in lengthy discussions of art, science, and politics in the late night on the Ramblas.

In the spring of 1902, with one foot in Paris and the other one in Barcelona, after a leisurely dinner (remember, it begins around ten), Picasso often promenaded up Las Ramblas to meet friends and play the slot machines at the Moderniste Café Torino on a corner across from the Plaça de Catalunya.

Exit on Rambla del Caputxins and walk toward the port for two and one-half blocks, then turn right under the large sign above the Nou de la Ramblas, a narrow thoroughfare that borders on the formerly notorious Chinese barrio, in which you will probably have a difficult time finding a person of Chinese heritage.

1. Inspiration for Picasso painting
Carrer Nou de las Ramblas (formerly Carrer Conde Alsato) 6

On the back of Picasso's work, *La Celestina,* painted in March 1904, he wrote the name Carlotta Valdivia, a resident of La Escolera, a house of prostitution formerly situated here. Picasso considered this depiction of a dignified one-eyed madam with a mantilla draped over greying locks to be one of his most important works.

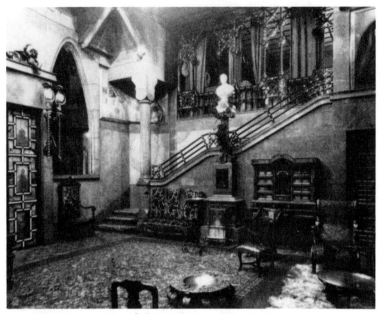

Drawing room of the Palau Güell. (Courtesy Arxiu Mas Ajuntament de Barcelona)

2. Palau Güell, Design of Gaudí
Carrer Nou de Las Ramblas 3–5

While working at Eudaldo Punti's iron workshop supervising the construction of a glass showcase for the glovemaker Estreban Comella to be displayed at the upcoming Paris Exposition of June 1878, Gaudí was introduced to Count Eusebio Güell i Bacigulpi. Güell, a textile manufacturer, was an immensely powerful member of the growing Catalan industrial bourgeoisie and had married into the great aristocratic Comella family. Due to his extensive business contacts in England and France, Güell was sophisticated and well traveled. Gaudí benefited from Güell's wealth and progressive outlook when Güell became his patron and close friend. The noted Catalan writer-philosopher Francesc Pujols (whom Dalí considered the greatest) wrote, "There exists between the city of Barcelona and Gaudí the unique phenomenon of a perfect convergence in time, the perfect harmony of a matrix awakened by the spirit that is destined to make it dynamic and immortal—the symbol of every renais-

sance." The palace, under construction for the ten years between 1886 and 1896, was planned to be the new city residence of the Güell family. The austere and dark exterior was designed with an arcade to connect the structure to another Güell building around the corner at Rambla de Centre 30, for which Gaudí designed a laundry facility on the roof. Next door to the palace, at number 9, Gaudí also designed a rooftop residence for the family's doorman.

Sculptural cone-shaped chimney pots covered with broken pieces of *azulejo* tiles and a decorative entrance break the stark stone exterior of the Palau Güell. Enter the building to see the main hall, whose center ceiling-hole for light opens all the way to the roof. When supervising this construction, Gaudí confided to his patron that he discovered only two people who liked the design of the palatial residence: Güell and himself. Some of the current furnishings date from the late eighteenth century. Clapés painted four large paintings for the main sala. A school and the Museu de les Arts de l'Espectacle with exhibits of various objects and collections about the performing arts and the theater, including an eclectic collection of posters and puppet theater programs, are housed here. The Amics de Gaudí (Friends of Gaudí) preservation group had their archives and headquarters in the building from 1952 until they were evicted by the directors of the theater museum in 1969. They then moved to their present location, the former Gaudí home in the Parc Güell.

Across the street, at what is now the Hotel Güell, look for a small rounded doorway.

3. Studio of Picasso, Café Eden Concert Carrer Nou de las Ramblas 12

Upon Picasso's second return from Paris, in January 1902, the restless young artist shared a studio located on the roof of this building, above the café, with sculptor Angel Fernándo de Soto. The gregarious de Soto was accustomed to filling the studio with boisterous friends, especially in the evenings when Picasso liked to work, so he soon moved out and left his friend to paint in solitude. In the early morning, Picasso walked to his family's apartment on Carrer de la Mercè (Walk One, #7). Now quite a dandy, Picasso dressed in fashionable trousers, slightly tied at the ankles, sported a bow tie, and wore a broad-brimmed black felt hat. He carried

a walking stick, then fashionable with the young Barcelona bohemians. Paris was still in his thoughts and by the fall he again returned to the excitement and stimulation of Montmartre.

Describing Picasso at this time, Gertrude Stein wrote: After the French influence, he became once more completely Spanish. Very soon the Spanish temperament was again very real inside him. He went back to Spain in 1902 and the painting known as his blue period was the result of that return. The sadness of Spain and the monotony of Spanish coloring, after the time spent in Paris, struck him forcibly on his return there. Everything that was Spanish impressed itself upon Picasso when he returned there after his second absence.

The Eden Concert was a favorite café of Picasso and the young intellectuals and art students. Here, in 1889, Mateu Fernando de Soto, Angel's brother, first introduced himself, and later Sabartés, to Picasso.

Proceed straight ahead for about fifty yards on the right side of the street until you are opposite the corner of Carrer Guàrdia.

4. Design of Gaudí
Carrer Nou de las Ramblas 32

The simple flat façade of this structure with iron balconies was remodeled by Gaudí in 1900 for his friend and longtime personal physician, Pedro Santaló. Around 1910, Gaudí suffered a serious attack of undulant (Maltese) fever. Accompanied by Dr. Santaló, he spent nearly four years recuperating in the town of Puigcerda on the Pyrenean border. Gaudí must have believed he was fatally ill for, on 9 June 1911, he dictated his last will and testament. After his recovery, he concentrated nearly exclusively on designs of religious structures. Gaudí was a fervent Roman Catholic who said: "The man without religion is a man spiritually ruined, a mutilated man." He could be seen as early as five in the morning praying in the Barcelona Cathedral, and he always ended his working day with prayers in the oratory of Sant Felip Neri.

Turn right at the next corner and continue down this colorful barrio street with drying laundry hanging from upper balconies, beckoning prostitutes leaning against the ancient walls, and the ever-present police van.

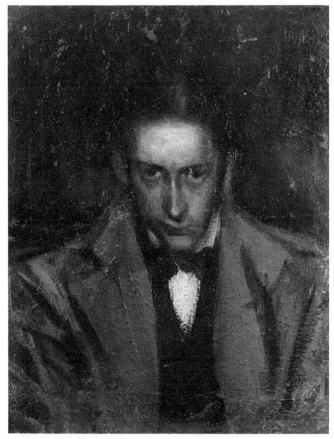

Portrait of Carlos Casagemas by Pablo Picasso, 1899–1900, Barcelona. (Courtesy Museu Picasso, Barcelona)

5. Studio of Carlos Casagemas i Coll
Carrer Sant Ramon

Somewhere on this block, from 1899 to early 1900, Casagemas (1880–1901) maintained a studio before he and Picasso moved into a dilapidated building on the Carrer Riera de Sant Joan. (Both street and building later disappeared in a redevelopment project of the dreary, threatening Chinese quarter.) The aristocratic-appearing Casagemas, just one year older than his friend, was the son of the consul general of the United States in Barcelona. On many Sunday afternoons the unconventional group from Els Quatre Gats

gathered here to drink *cremat* (coffee and flaming rum) through straws, recite poems, deliver fiery political speeches, and fervently sing "Els Segadors," the oft-prohibited Catalan marching anthem.

In September the two young artists traveled by third-class coach to Paris to attend the 1900 Universal Exposition where Picasso's work *Last Moments* was on exhibit in the ten-year survey of painting held in the Grand Palais. They were also excited to be visiting the city that held a powerful attraction for the Catalan artists who, for the previous twenty years, had been drawn to the center of the modern art world. By Christmas, Picasso had returned to Barcelona; and in February of the next year, Casagemas was buried in Barcelona after shooting himself in Paris during an argument with Germaine, a Montmartre prostitute and artist's model who later married Ramón Pichot. During those few months in Paris, Picasso's painting technique changed. From the impressionistic bold colors reminiscent of Toulouse-Lautrec in which Picasso portrayed café life in Montmartre in his 1900 *Le Moulin de la Galette,* now his 1901 *Absinthe Drinker,* his *The Blue Room,* and a self-portrait in 1901 were landmark examples of his natural love of blue and his brooding symbolistic new style of painting that would dominate his work for the blue period of the next four years.

Continue for two blocks to Carrer de Sant Pau and turn right through the Plaça Salvador Seguí, heading back toward Las Ramblas del Caputxins.

6. Design of Domènech
Carrer San Pau 9–11, Hotel España

Inside the striking Moderniste façade of this hotel most of the original decorations by Domènech are still intact. The lobby is distinguished by elaborate woodwork, painted murals, huge brass chandeliers, and a chimney four meters high designed by the noted sculptor Eusebi Arnau. Sneak a peek into the dining room with its unusual walls of wood intermingled with convex colored, glazed tile. The hotel was built in 1902–3. Despite Domènech's apprenticeship of several years with Gaudí, he was perceived differently by architectural critics. To some he represented the bridge between the Modernisme movement and the later Noucentistes, the artists and writers in Spain who, after 1911, reacted against Catalan

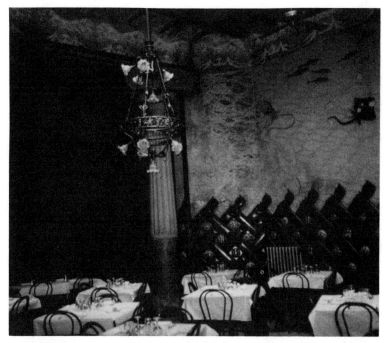

Dining room of the Hotel España. (Mary Ellen Jordan Haight)

modernism. Along with the artist Joaquim Sunyer, Domènech set the pattern for an evolvement to a European provincial classical style—a transition between Modernisme and the spare functional architecture typified by the works of Josep Lluís Sert.

Continue down to the corner and jog right on Las Ramblas.

7. Gran Teatre del Liceu (Opera Theater) Rambla del Caputxins

This first lyric theater in Barcelona is second in size only to the great La Scala in Milan. Designed in 1848 by Gorrigo i Roco, the structure was completed by Josep Oriol Mestres (1815–1895). In 1882, with Wagnerism sweeping over Europe, a performance of his opera *Lohengrin* here resulted in the discovery by many Catalans of European classical music. Over a hundred years later, in 1989, Leonard Bolado's opera *Cristol Colon* (Christopher Columbus) was premiered here with internationally renowned Catalan tenor José Carrera as

Chris and Montserrat Caballé singing the role of Isabel I.

We strongly recommend attending a performance in the opera house. This is one of those places where our words cannot adequately describe the visual impact of the lobby, with its majestic central staircase and the gold-and-crimson furnishings and décor of the lofty hall, its ceiling garnished with paintings that allude to the major works of previous illustrious authors and playwrights. In 1933, Miró contributed his modern painting *Peintures segons un collage* to the theater. The least expensive seats have a good view, and the well-attired cosmopolitan crowd is interesting to observe.

Return up Las Ramblas, away from the sea, for about fifty yards, then cross to the center promenade.

8. Pavement design of Miró
Plaça Boqueria

The colorful pavement mosaic was designed by Miró in a geometric abstract of red, yellow, and blue bordered by black stones. This is an example of city beautification by using a modern Catalan design on a prosaic sidewalk.

On the opposite side of Las Ramblas, take the first small street to a sharp left on Carrer Cardenal Casañas and proceed to the Plaça del Pi. Facing on the square is the Eglesia de Santa Maria del Pi (Pino Church) and the small corner store where Picasso visited the sacristan's son, fellow art student Joan Vidal i Ventosa. After an immediate left through the plaza, enter the narrow passageway of Carrer Tetritxol.

Notice the tiled plaques on the walls of the adjoining houses. Number 2 was the residence of Antoria Gili i Güell, a poet who lived from 1856 to 1909; and number 4 is the house where Angel Guinera, a poet and dramatist (1847–1924), died.

9. Sala Parés
Carrer Petritxol 5

On the wall outside this gallery which exhibits mainly the works of Spanish artists is, appropriately, a plaque in memory of Santiago Rusiñol. In May 1901, when the Sala Parés was the only gallery to show the works of the young modernists, an exhibit of a collection of pastel drawings by Picasso was opened. A review in the Catalan magazine *Pèl i Ploma* (Pen and Brush), edited by Miguel Utrillo and illus-

trated with a Casas portrait of Picasso, stated: "The pastels which figure in the exhibition organized by our publication at the Salon Parés reveal but one aspect of Picasso's talent which is going to be discussed a great deal but not less appreciated by all those who, scorning the superficial aspect of art, seek the essence beneath appearances."

At this time, Picasso was on his second train trip to Paris. Commenting on the unfavorable reaction to his collection of pastels by some of the public, he wrote to his friend Joan Vidal: "I can imagine the reaction of the illustrious bourgeois upon seeing my exhibition at the Sala Parés, but that ought to be as important to us as applause, that is to say, as you already know: if the wise man doesn't approve, bad; if the simpleton applauds, worse. So, I'm content."

At the end of the street, jog slightly to the right and look up the Carrer d'en Bot, where you will see remnants of an old theater entrance on your left.

10. Design of Gaudí
Carrer d'en Bot 1, formerly Sala Mercè

Set between the Rambla de Estudis and Carrer d'en Bot, the cinema theater Gaudí designed in 1904 for painter and entrepreneur Lluís Grana y Arrufi was unsuccessful and was later replaced by the existing Teatro Atlantico. Only recently discovered, Gaudí's original plaster décor was preserved in the basement of this theater.

Continue to your right up the Carrer Portaferrissa which, in a couple of blocks as you pass through the Plaça Cucurulla, becomes Carrer Boters, and enter the Avinguda Catedral.

11. Picasso frieze
Plaça Nueva, Colegio de Arquitectos de Cataluña (Architect's College of Catalonia)

Dominating the front of the architectural college is a large concrete frieze designed by Picasso and unveiled in April 1962. The cartoon designs, inspired by traditional Catalan dances and festivals, were sandblasted into the hard façade. Domènech began teaching here in 1877 and was elevated to director in 1900 and again from 1905 to 1919. Because of his interest in archaeology, he became a pioneer in combining the great designs of the Romanesque and Gothic periods in architecture to launch specifically Catalan Modernisme.

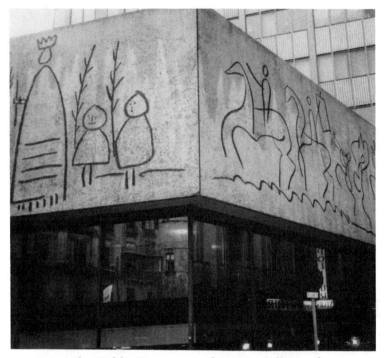

*Frieze by Pablo Picasso, Architect's College of
Catalonia, Barcelona. (James Jordan Haight)*

Domènech taught his students that interaction was the essence of the entire new modern movement, the appreciation of a historical legacy combined with the urge to be abreast of modern European fashion. The college hosts activities and shows and publishes a guide to the architecture of Barcelona.

Across the Avinguda Catedral, in the Plaça de la Seu in front of the magnificent Barcelona Cathedral, after Sunday morning mass, one can hear the sound of reedy music from a twenty-one-piece band in a corner of the square as they accompany informal groups of people enthusiastically dancing the sardana, the Catalan national dance of dances. The casual groups of dancers, some wearing white espadrilles, form circles around piles of discarded coats to perform the formal repetitive steps. The performers can also be observed (and joined) on late Sunday afternoons in the Plaça Sant Jaume.

Proceed on Avinguda Catedral to the Plaça Antoni Maura, cross Via Laietana, and turn left. Walk one block, then turn right and go about three blocks farther.

12. Birthplace of Isidro Nonell
Carrer Sant Pere Més Baix 38

Nonell was born in this building on 30 November 1873. In 1893 he passed the entrance exam for La Llotja, where his fellow art students and friends were Ramón Pichot, Ricardo Canals, and Joaquim Mir. Eight years Picasso's senior, Nonell first visited Paris in 1897 and then in 1901 loaned his studio on the rue Gabrielle on Montmartre to his good friend Picasso. Nonell's strong social concern for the underclasses was reflected in his splendid realistic pictures; he was the first to depict the derelicts, beggars, prostitutes, and gypsies of the Chinese barrio in Barcelona. These vivid, realistic paintings affected Picasso so strongly that his work also began picturing the impoverished Spaniard. Although Picasso is the best known Spanish artist in the world, Nonell, the man who so greatly influenced his early work, is little known outside of Catalunya.

13. Studio of Miró
Carrer Sant Pere Més Baix 51

In his first independent studio, away from his family's apartment, Miró shared the room here with another painter. It was here he painted his initial still-life works. Later, when living in Paris in 1938, Miró wrote of this time:

In Spain . . . I never had a real studio. In the beginning I used to work in such tiny cubby holes I could hardly squeeze in. When I was dissatisfied with my work I used to bang my head against the wall. My dream . . . is to have a very large studio, not for the light . . . but to have room and to have lots of canvases for the more I work the more I want to work.

Because he was so shy, Miró preferred to work alone, shunning publicity, only desiring to be remembered as an artist who worked hard and honorably.

Reverse your route for about two blocks and turn right at Carrer Mare de Deu del Pilar. Travel this street to its end at Carrer de Sant Pere Més Alt, turn left, then jog right.

41

14. Design of Domènech
Carrer Amadeo Vives 1, Palau de la Música Catalana
(Catalunya Music Palace)

This concert hall is believed to be one of the finest ceremonial structures produced in the Moderniste style, incorporating ideas and motifs from Art Nouveau to Moorish revival. The building, in its beauty as well as in its creative details, reflects the turn-of-the-century renaissance of native Catalan traditions that assimilated medieval architecture and tile work with the ornamental genius of the Mudéjar culture (Christian art influenced by Moorish art in the reconquered Spain of the twelfth to fourteenth centuries.) Due to the advanced technological design of what is essentially a steel-framed glass box, the hall is often cited as the original example of the rationalist style in Barcelona. Notice the manner in which an addition was built to house the new box office, staircase, and entrance in what was originally the rear of the building. This is another site where we recommend that you see the interior by purchasing tickets for a performance.

The idea for a concert hall devoted specifically to Catalan music was born in the cultural euphoria that filled Barcelona for the 1888 Universal Exhibition. Although at this time Barcelona was the trade, industrial, and mercantile capital of Spain, the exhibition emphasized music, with orchestras converging in Barcelona from all over Europe. Upon the completion of the exhibition, some Catalans, led by composer and conductor Lluís Millet, proposed a permanent center for secular choral folk music sung by the celebrated twenty-eight-member Orfeó Català chorus, at this time the most important choral group in Europe. The architect would have to be Catalan because the hall was planned as a symbol of the resurgence of Catalan nationalism and an ecstatic assertion of its roots in the past. Domènech, a political activist, was clearly identified with the Catalan independence movement; and in 1901 he was one of four Catalan citizens elected to the Madrid parliament. This building became his symbol of an oppressed culture and a corresponding call to Catalan nationhood. In the spring of 1905, after the Orfeó Català organization had raised six hundred thousand pesetas to fund the hall, work was begun on the unusual wedge-shaped lot designated for it. Richard Strauss and the Berlin Philharmonic played the inaugural concert in 1908.

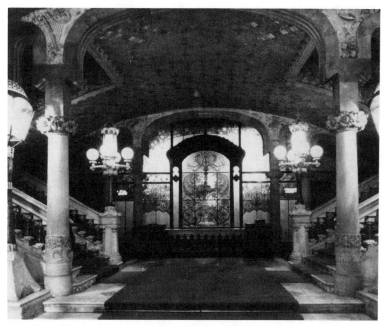

Double staircase to the concert hall of Palau de la Música Catalana. (Courtesy Oficina Tècnica d'Imatge, Ajuntament de Barcelona)

The design employs an iron frame so as to keep columns in the concert hall to a minimum; windows are used as walls and a great hole cut in the roof adds even more light. The glittering foyer, with its walls of pink-and-pale-green stained glass and its stunning staircase supports of amber glass with a golden twist of ceramic through the middle, almost over-whelms the first-time visitor. The entrance is just a small taste of what waits in the three-tiered concert hall. Here, dazzling color blazes from ceramic-, stone-, and stucco-adorned walls. Huge medieval chandeliers illuminate the spectacular scene. On one side of the facing proscenium is a bust of popular Catalan musician Anselm Clave, an homage to the local tradition of popular music, and on the other side Wagner's *Die Walküre* cavalcade rises above the doric columns that frame a bust of Beethoven. The flowing tree on one side is a symbol of national unity and a cultural identity rooted in the Catalan soil. On the other side, painted clouds represent spiritual unity with the European continent. The

rational, or functional, influence appears in the advanced acoustics, the plan for the movement of masses of people throughout the building, and the integration of the performance with the audience. Such concerns are now universally accepted as part of the total design of a music auditorium, but they had their initial roots in this remarkably progressive structure.

Josep Plau, the late Catalan writer, wrote in 1918:

I do not ask that the Palau be torn down . . . just that its concert hall be made mediocre, simplified so that people with a visual bent can go there and listen to music without having to shut their eyes. . . . The place is all excess—feverish, disturbing, a jumble.

Pau [Pablo] Casals, the supreme Catalan musician of the twentieth century, thought of the palace as his second home. Today, international groups such as the London Philharmonic Orchestra and Chorus and the Philharmonic Orchestra of St. Petersburg perform here. Although many critics view the palace as the zenith of Domènech's career, history has not recorded the reason why he never visited his completed masterpiece.

Continue down the Carrer Sant Pere Més Alt to Via Laietana and cross it, then turn left. Just past the front of the police station, take the first small street on the right—Carrer Julià Portet, which after one block changes to Carrer Montsió—and follow it almost to its end.

15. Design of Puig and Bohemian Café-Cabaret
Carrer Montsió 5, Els Quatre Gats

Just as art-loving pilgrims flock to the infamous Montmartre haunts of the early Paris bohemians and intellectuals, so the restored Four Cats is a must on the Barcelona itinerary of all aficionados of the arts. While in Paris, artist-impresario Pere Romeu and his friends Rusiñol, Casas, and Miguel Utrillo, the leaders of the Catalan Moderniste movement, had frequented the Chat Noir tavern. In his fervor to recreate in Barcelona the stimulating and sometimes raucous *ambiente* for unconventional poets, painters, musicians, sculptors, journalists, and playwrights, in 1897, Romeu opened the Four Cats "beerhall, tavern-inn." This new establishment, possibly named for Romeu and his three friends, was located in a brick neo-Gothic structure designed by Puig in 1895–96. It was not

Ramon Casas and Pere Romeu in Tandem, *painting by Casas. (Museu d'Art Modern, Barcelona)*

long before the avant-garde gathered at what Rusiñol described as "a place to cure the ill of our century, and a place for friendship and harmony." The large rear room, now a restaurant, was the scene of readings, concerts of modern music, theatrical presentations—including novel shadow puppetry by Utrillo—and informal art exhibits.

As this is the final stop on this walk, take time for a meal in the revived interior. In your imagination it will be the turn of the twentieth century. Photographs from the six brief years of its original existence picture the Sala Grande, adjoining two front rooms, exactly as it looks now, with furniture designed by Casas, gleaming colored tiled walls, heavy dark wood beams, and wall decorations in carved stone and iron. A reproduction of the large Casas painting picturing himself and Romeu dressed in white suits and black stockings astride a tandem bicycle hangs in the same place as the original did; that painting is now in the Barcelona Museum of Modern Art.

The English-speaking proprietor will seat you at a marble-topped table in the spacious rear room where jazz concerts are regularly held. The menu cover, drawn by Picasso in 1899, depicts well-dressed Victorian couples seated at round tables set on the narrow side alley in front of a side entrance.

Casas, Rusiñol, and Nonell were the initial leaders of the informal Cercle de Els Quatre Gats; but when Picasso joined the group a couple of years later, it included his cohorts Ramón Pichot, Sebastiá Junyer, Sabartés, Casagemas, and the de Soto brothers. For them, as for other young artists, the tavern provided a needed opportunity for exposure. At the time, only the works of the well-established older artists were shown in local galleries in Barcelona; the opportunities for novices were virtually nonexistent. Some of the writers and poets found outlets for their work in small magazines, especially in France and Germany, and Casas and Utrillo edited two minor Spanish art journals. The collection of framed portraits hanging on the walls below the dark wood balcony today recreates a 1900 showing of drawings by Picasso. Casas painted stylish portraits of distinguished Barcelonans, many of which were exhibited at the Sala Parés. In response, Picasso's friends organized their own show at Els Quatre Gats, tacking up unframed sketches of priests, whores, musicians, dancers, poets, and artists (themselves) in a parody of Casas's society subjects. Utrillo, in a mock critical review of Picasso's works on display, dubbed the artist "little Goya." In two weeks only a few of the 150 drawings sold; for from one to five pesetas each to some of the regular customers, who always had time to sit over a cup of coffee.

You undoubtedly noticed the wall plaque next to the door when entering the building. The Cercle Artistic de Sant Lluc existed from 1902 to 1936. Support came from the guild of Catholic artists in protest of the modernist reforms. The members' art style reflected a conservative religious version of Symbolism, as seen in the pious appearance of sculptures by Josep Llimona, a leader of the movement along with Gaudí.

Carrer Montsió concludes at the expansive Avinguda Portal de l'Angel lined with smart shops and strolling musicians. Turn right and walk the few blocks to the Plaça de Catalunya, where you can take the Metro Catalunya to your hotel or continue to the start of the next walk.

WALK

THE
GOLDEN
SQUARE

THREE

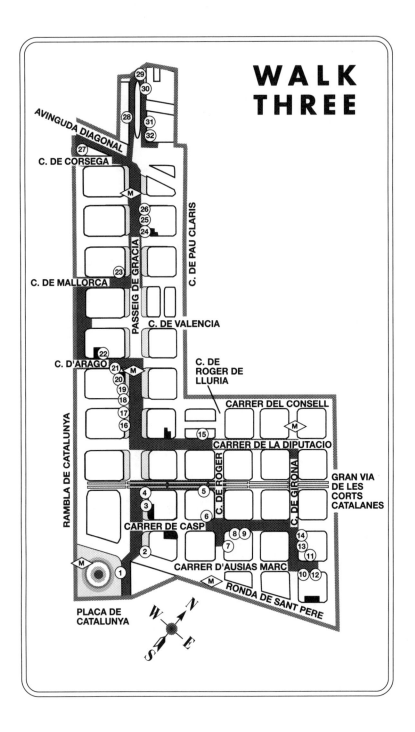

WALK THREE

AVINGUDA DIAGONAL

C. DE CORSEGA

C. DE PAU CLARIS

PASSEIG DE GRACIA

C. DE MALLORCA

C. DE VALENCIA

C. D'ARAGO

C. DE ROGER DE LLURIA

CARRER DEL CONSELL

CARRER DE LA DIPUTACIO

C. DE ROGER

C. DE GIRONA

GRAN VIA DE LES CORTS CATALANES

RAMBLA DE CATALUNYA

CARRER DE CASP

CARRER D'AUSIAS MARC

RONDA DE SANT PERE

PLACA DE CATALUNYA

N
W E
S

Metro Catalunya

The *Eixample,* or extension, area in Barcelona was developed during the urban expansion of the second half of the nineteenth century according to plans drawn by city planner Ildefons Cerdà. Filling a hundred-block tract, it was designed in the shape of a square, with straight streets running parallel to the sea cut perpendicularly by other mainly straight streets and diagonally by avenues. The project was completed at the height of the Modernisme period and coincides with the blossoming of modern architecture. The *Quadrat d'Or*—Golden Square—is the name used for the exhibition and catalog organized by the Olimpíada Cultural in 1990 on the subject of Modernisme and the movement of the residential center from the old city to the central Eixample. Toward the end of the nineteenth century, the bourgeois of Barcelona relocated their houses from the cramped old barrios to the top of Las Ramblas and beyond to new suburbs. This concentration of high-quality residential property gives us a view of the expansion of architectural Modernisme during the first decade of the twentieth century. The large private homes and apartment buildings are outstanding for their external designs and decorative façades. The interiors were treated with the same rich obsession for detail, resulting in an extraordinary consistency between outside and inside. The furniture and the decoration of the rooms to the very smallest detail echoed the building's façade. In 1900, the Barcelona City Council established the practice of offering annual architectural prizes, which contributed to the rich embellishment of the area's structures. At the height of the formation of this urban space into a center of artistic quality, the architect became the artist, who signed his work as a great creator of Modernisme splendor. In Barcelona, Gaudí, Domènech, and Puig were the leading architects of this period. Today, a large part of the unique personality of Barcelona is imprinted by the value of the magnificent architectural inheritance found in the Quadrat d'Or.

Walks three and four concentrate on the buildings designed by those architects who are responsible for Barcelona's international reputation for unusual and striking examples of Modernisme, as well as the parks and plazas they planned to enhance the human livability of the urban center.

Plaça Catalunya. (Courtesy Oficina Tècnica d'Imatge,
Ajuntament de Barcelona)

1. Design of Gaudí and sculpture by Josep Clará
Plaça de Catalunya

The expansive plaza with an ornate fountain and lush bright plantings is situated on what was formerly the outskirts of the city. Nineteenth-century residents wishing to escape the dark medieval streets of the barrios walked up Las Ramblas to a field intersected by a small flowing stream. Prosperous citizens built summer villas and weekend retreats here. Today the plaza is the heart of modern Barcelona and the focal point of all the city's major events, including the celebration of St. John's Day on 24 June with bonfires and dancing. In the center is the monumental fountain Gaudí probably designed in 1877 during his student years, and *La Deessa* (The Goddess), a sculpture by Josep Clará (1878–1958). The initial skirmish of the battle for Barcelona during the Spanish civil war, in May 1937, resulted in the seizure by government troops of the nearby telephone exchange from members of the trade unions. Barricades constructed of the square street cobblestones were built in front of the buildings lining Las Ramblas from the waterfront to this plaza. In his book *Homage to Catalonia,* George Orwell suggested that "Barcelona paving-stones ought to be numbered; it would save such a lot of trouble in building and demolishing barricades."

Exit the square by crossing Ronda de Sant Pere to the right side of the Passeig de Gràcia.

2. Design of Enric Sagnier i Villavecchia
Passeig de Gràcia 2–4, Cases Pons i Pascual

This block-long building constructed in 1891 by Sagnier (1858–1931) has a white stone exterior with a castle likeness. The site was originally two independent homes, one the property of Alexandre M. Pons and the other of Sebastià Pascual—hence its name. The houses were conceived jointly to make the best use of the great urban location. This earliest neo-Gothic construction of Sagnier is notable for his literal use of the turn-of-the-century architectural repertoire. The entire structure was fully restored in 1984 when a vertical extension set back from the façade was added to the roof. The original wooden chimney was preserved, and in the hallway there are still traces of the initial staircase with sculptural elements and iron-and-glass skylights popular during this period.

(Note: Cases denotes a multifamily dwelling)

3. **Design of Joaquim Bassegoda i Amigó**
 Passeig de Gràcia 6–14, Cases Antoni Rocamora

 Although architect Bassegoda (1854–1938) commenced this structure in 1914, he did not complete it until 1917. This building vies with the Casa de les Punxes (also identified as Casa Terrades in Walk 4, #3) by Puig for the distinction of being the largest Modernisme structure in terms of architectural volume in Barcelona. The architectural trend at this time was to place a number of smaller structures on a large lot. The Casa Rocamora heralded a new concept of unifying all of the apartments in a single massive architectural statement with uniformity enforced throughout the exterior of the building.

4. **Formerly Farmacia Gibert and**
 design of Josep Lluís Sert
 Passeig de Gràcia 16

 Before the existing Sert-designed building was erected in 1934, the mid-eighteenth-century Farmacia Gibert stood here. In 1879, Gaudí designed ornamental additions to its façade; it was demolished in 1895. In appearance it resembled the glossy-tiled Casa Antigua Figuroa on Walk One (#9). Sert collaborated with Joierica Roca in the design of the present massive corner building, a fine example of the spare rationalist international architecture in favor between the two world wars. Note the bas-reliefs on either side of the entrance that depict the technological development of Spain and its maritime dominance.

 Sert was born in Barcelona in 1902; in 1929 he graduated from the Escuela Superior de Arquitectura. During the rather confused and critical final months of the reign of Alfonso XIII in early 1931, Sert helped to found the post-Noucentisme group of dynamic young rationalist architects, *Grup d'Artistes i Tecnics Catalans per al Progress de l'Arquitectura Contemporania.* The word *España* was later substituted for *Catalans* to reflect more its Spanish national character. Although the two men were almost poles apart in architectural philosophy, J. L. Sert appreciated the role Gaudí played in the ingenious advancement of architecture: "In the continuous evolution of modern architecture, it is more than likely that Gaudí's last experiments will acquire increasing value and will be more fully appreciated. Then his importance as a pioneer and a prophet will be acknowledged." In 1958 Sert

became dean of the Harvard University architecture faculty and lived in the United States until his death in 1990.

Cross to the nearest tree-shaded pedestrian island of Grand Via de les Corts Catalanes, turn right, and walk away from the Passeig de Gràcia for a couple of blocks.

5. Design of Sagnier
Gran Via de les Corts Catalanes 654, Casa Camil Mulleras

Constructed in 1905 with an exterior of dark stones and iron balconies, the casa has an interesting center courtyard reached through glass entrance doors opening to a hallway. The sculptural details of the stones and the wooden cornice are representative of other building designs by Sagnier.

Continue to the corner of Carrer de Roger de Llúria where the Ritz Hotel sits, take a right and walk for one block, then turn right on Carrer de Casp.

6. Design of Adolf Ruiz i Casamitjana
Carrer de Casp 22, Casa Llorenç Camprubí

The colorful glazed-tiled balconies on the street and first levels make the exterior of this house a significant landmark as well as a fine example of the designs of Ruiz (1869–1937) at the turn of the century. His use of neo-Gothic forms and elements stamped his work with his own personal interpretation of the novel architecture.

Reverse your steps to Carrer de Roger de Llúria, turn right, and stroll half a block.

7. Design of Vilaseca
Carrer Roger de Llúria 8–10 and 12–14, Casa Joaquim Cabot

This house was started in 1901 for Joaquim Cabot and his family and was completed in three years. Although Vilaseca was not considered a pioneer of Modernisme design as were Gaudí, Domènech, and Puig, his contributions are significant because of the orientalism he incorporated into his designs. The house at 12–14 is six stories high with wrought-iron balconies and tall bay windows with exterior concrete embossed flowers. The separate adjoining building at 8–10, originally part of the same structure, shows a Moorish influence, especially in the concrete geometric patterns over the

door, the intricately patterned tiled and wrought-iron balconies, and the face of dark stone that could use a washing. A peek through the glass entrance reveals a hallway with unusual designs on the walls and ceilings and distinctive, original lamps. Because of the triangular shape of the lot, the two buildings have different shapes. Number 8–10 has a normal bulk and depth distribution because it is situated on the wide portion of the property, while the building next door, be-

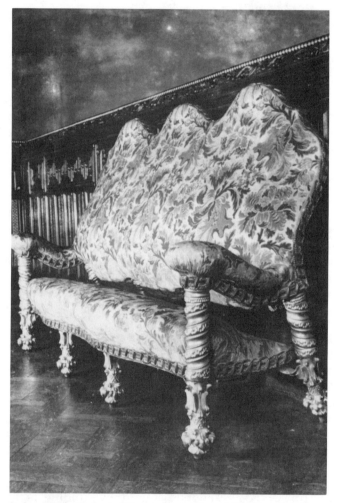

Sofa at Casa Calvet. (Courtesy archive of Catedra Gaudí, Barcelona)

cause it is on the narrow portion, is deeper and consumes more of the land.

Return to the corner of Carrer de Casp and turn right.

8. Design of Juli Batllevell i Arús
Carrer de Casp 46, Casa Antoni Salvadó

Distinctly different in appearance from its neighbors, this structure presents an alternative to the usual design of central city apartment houses built at this time (1902–3). Most of the multiple dwellings were in the Modernisme style, but the architect Batllevell (1864–1928) elected to maintain a strictly conservative historical treatment. His use of traditional materials and detailed workmanship is displayed here. The "crowning feature" on the upper floor is a dramatic sweeping multiple-arch gallery later weakened architecturally by the addition of another floor.

9. Design of Gaudi
Carrer de Casp 48, Casa Calvet

Gaudí orchestrated the building of this house for the textile manufacturer Pedro Martin Calvet. The adjoining apartment and business sites were designed for the use of Calvet's sons. Both buildings were erected during 1898 and 1899, but work continued for the next five years on the complex interior adornments. This design is among Gaudí's most conservative, as the narrow five stories appear to be in more of a baroque than a Modernisme style. Note the brackets decorated with realistic stone carvings of fruit and berries that support the balconies and bay windows above the central entrance. The lower half of the walls of the interior staircase that wraps around the elevator shaft are covered in bright azure-blue Delft tiles and bunches of painted cement grapes. The polished wood handrails are drawn into a berrylike knob at their conjunction with the corners of the supporting granite columns. Look closely at the huge door knocker on the entrance: as it is employed, a Christian cross squashes a malicious beetle.

The singular importance of the Calvet house is that Gaudí designed it with the unusual concept of a "quality pluriform building," meaning that the various parts and details that make up the whole building receive unique and different treatments due to Gaudí's unusual designs. You can see the

finest example of this in the entry hall, doors, walls, staircase, ceilings, and elevator. Compare this to present-day apartment houses.

In 1900 Gaudí was presented with the first annual prize in architecture by the Ajuntament de Barcelona for the highest quality structures completed during the previous year. Although Gaudí was one of a few extravagant and original Catalan architects, he stated that "originality must not be sought after, since doing that leads to extravagance. It is sufficient to see what is usually done and try to improve on it." Politically, Gaudí was such a fervent Catalan that he refused to speak the Castilian dialect of Spanish, speaking only in Catalan even in the presence of King Alfonso XIII.

Continue on Carrer de Casp to Carrer de Girona, turn right, and proceed to the next corner, Carrer d'Ausiàs Marc.

10. Design of Francesc Berenguer i Mestres Carrer de Girona 18 and Carrer d'Ausiàs Marc 30–32, Cases Francesc Burés

Many prominent designers collaborated with Berenguer (1866–1914) on this building during its five-year construction beginning in 1900. This integration of diverse arts to fabricate the Modernisme style was usual, and some of the most gifted artisans of the period often collaborated. Three of the best known whose works are found here include furnishings designer Gaspar Homar; Pau Roig, an exceptional artisan of marquetry (inlay of various colored woods and other materials most often found in furniture and on interior walls and ceilings); and mural and stained-glass artist Oleguer Junyent. Viewed in its entirety, Cases Burés is one of the more fascinating Modernisme houses since its interior—particularly the ornamentation of the entrance hall and the street-level rooms—is representative of high-quality crafts. You can enter the courtyard and see the intricately detailed staircase, stained-glass windows, and unusual caged elevator.

The exterior is notable because of the diverse parallels that exist between the Cases Burés and other nearby buildings constructed years before it. Berenguer also worked alongside Gaudí in projects for the Güell family. Lifelong and intimate friends, they were both from the small town of Reus, where they studied at the school run by Berenguer's father. Although he had a reputation for being a careful organizer

and a hard worker, Berenguer never completed his formal architectural studies because of the responsibilities he accepted with an early marriage.

11. Design of Sagnier
Carrer de Girona 20 and Carrer d'Ausiàs Marc 33–35, Cases Antoni Roger

Another large corner apartment house at this intersection also has an address on each of the two streets. The three Roger brothers—Antoni, Tomàs, and Enric—hired Sagnier to plan apartment houses on large pieces of property. These three structures are fine architectural examples of the years (1888–90) just preceding the Modernisme era, although they are each notably different. Cases Antoni Roger is distinguished by the architect's design solution to the problem presented by a forty-five-degree-angled corner lot. As early as 1888, the style of the Catalan Gothic palace represented by this building's design was adopted; it was later to appear in some of the most important Moderniste works. Again, the entrance hall exhibits typically elegant details of Modernisme, such as the lighting fixtures and highly varnished carved wood.

Turn right on Carrer d'Ausiàs Marc and walk one-half block.

12. Design of Sagnier
Carrer d'Ausiàs Marc 37–39, Cases Tomàs Roger

A few years later, in 1892, Tomàs Roger began construction of his house in two stages: first, number 37, with its back to Cases Antoni Roger (a smaller structure); and, two years later, due to the acquisition of an additional parcel of land, number 39. The two houses on this site originally had roofs very similar to those of Cases Antoni Roger around the corner.

Return to the corner of Carrer d'Ausiàs Marc and Carrer de Girona and turn right.

13. Design of Sagnier
Carrer de Girona 22, Casa Antoni Roger

The next Roger family house is notable for the vast ground-floor space used for the family's textile-related businesses. Because of the very lucrative textile manufacturing activities pursued by the Roger family and others, the whole

of the Eixample de Sant Pere became a noteworthy—and wealthy—enclave of fabric tycoons whose new wealth was instrumental to the Catalan Renaissance of the fin de siècle.

Barcelona has been a major textile center for over two hundred years; the nine thousand mechanical looms and thirty-six hundred Catalan factories located here in the nineteenth century were strongly competitive in the European market. To this day, some of Barcelona's finest fashion houses are located on these streets. Watch for the models darting across the intersections.

14. Design of Sagnier
Carrer de Girona 24, Casa Enric Roger

This Roger home, constructed the same years as Antoni's next door (1888–90) is similar to its neighbor. More upper floors have since been added, and the façade of the fifth floor has been intricately embellished.

Numbers 46 and 54 in the next block are interesting, the former because of its simplicity and the latter because it took five years to construct.

Continue along Carrer de Girona until you reach Carrer de la Diputació, then turn left and stroll two and a half blocks.

Beginning in 1894, Gaudí lived with his niece at number 339 on this street for twenty years before moving to a house in Park Güell (Walk 5, #3). As you pass number 329, note the sweeping gallery on its columned façade.

15. Design of an unknown architect
Carrer de la Diputació 299, Casa Marcel-lí Costa

Reconstruction on the original 1862 house at this address was initiated in 1902 by Teresa Quadreny in the name of *Ensanche y Mejora de Barcelona*. (Expansion and Improvement of Barcelona), a company formed to assist in the urbanization and construction of the Eixample. Like many other houses in the area, this one was rebuilt to include glazed balconies and to transform the semibasement and mezzanine into a ground-floor commercial space.

Continue on to Passeig de Gràcia and turn right.

16. Design of Joaquim Codina i Matalí
Passeig de Gràcia 27, Casa Manuel Malagrida

Designer Codina (?–1910) hired Pere Ricart to do the decorative plastering in the dining room during construction in 1900–1908. Like many other buildings on most of the central

streets of the Quadrat d'Or, the exterior face is reminiscent of a minor urban palace. Unlike most palaces, however, it was not planned to be a single-family residence but was for multi-family use.

17. Design of Domènech
Passeig de Gràcia 35, Casa Lleó Morera

Francesc Morera and his son Lleó commissioned Domènech to remodel the corner house that, along with its twin, was originally built in 1864. The renovations were completed in 1902, making this house the finest example of Domènech's design of private homes. Look for his signature

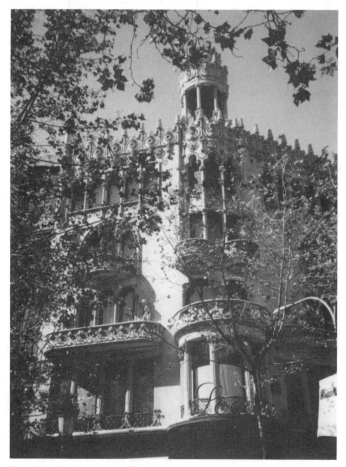

Casa Lleó i Morera. (Mary Ellen Jordan Haight)

carved in the cement geometrical arrangement of large flowers on the front. Morera's house now represents one of Modernisme's richest and best preserved examples of the applied arts. Most noteworthy of the decorative elements are the mosaics by Mario Maragliano and Lluís Bru, stained-glass windows by Rigalt and Granell, wood marquetry on the ceilings and floors by Escofet, and Gaspar Homar furnishings in the interior. The façade of the ground and first floors includes the sad remains of what once were magnificent sculptures by Eusebi Arnau. Not surprisingly, this building won the city council's 1906 architectural competition.

18. Lamp posts designed by Pere Falqués i Urpí
Passeig de Gràcia

Lining this tree-shaded divided boulevard are the elaborate iron lamp posts the city commissioned to Falqués (1850–1916), an architect popular among municipal authorities. Falqués and Domènech both qualified as architects in 1873, but Falqués designed more municipal projects, including the plazas surrounding the Casa de la Ciutat, the 1883 renovation of the Gran Teatre del Liceu, and the 1896–97 project Hidroelectrica de Catalunya.

19. Design of Sagnier
Passeig de Gràcia 37, Casa Ramón Mulleras

On the same side of the street is the final house to be restored along this part of the passeig. Originally constructed in 1868 for the well-known artist Ramón Casas by the Barcelonan master builder Pau Martorell, the structure was rebuilt and the façade completely reconstructed by Sagnier in 1910–11. The simple entryway is distinctive of late Modernisme-Noucentisme.

20. Design of Puig
Passeig de Gràcia 41, Casa Amatller

Within the area known as the *Mansana de Discordia* (Apple of Discord), the Amatller family home (1898) was the first to be restored and reconstructed around an already existing structure originally built in 1875 by architect Antoni Robert. In the remodeling, Puig employed a typical urban Gothic house scheme to give it the appearance of a small palace inhabited by a single family. Puig's classic, colorful, and creative remodeling of the exterior was completed in 1900. Notice the highly detailed geometric patterns of set-in

Interior door and elevator at Casa Amatller. (Courtesy Oficina Tècnica d'Imatge, Ajuntament de Barcelona)

tiling. The building integrates medieval traditions in southern Spain with the artisan movement of the late nineteenth century in Barcelona.

The youngest of the big three Catalan Moderniste architects, Puig straddled Modernisme and the rise of Noucentisme in about 1911. The former student of Domènech studied and wrote about Romanesque architecture, coining the phrase "First Romanesque" to describe the small-scale seventh- and eighth-century Spanish churches. Despite a relatively short working career of just fifteen years, his wide travels and exposure to other European cultures, coupled with his academic excellence, enabled him to add historical depth to an understanding of medieval architecture, along with the mathematician's scientific acceptance of the evolving machine age.

21. Design of Gaudí
Passeig de Gràcia 43, Casa Batlló

Although originally constructed for the Felio Batlló i Barrera family in 1875 by architect Emili Sala i Cortés (1841–1920), the present appearance of the Casa Batlló is attribut-

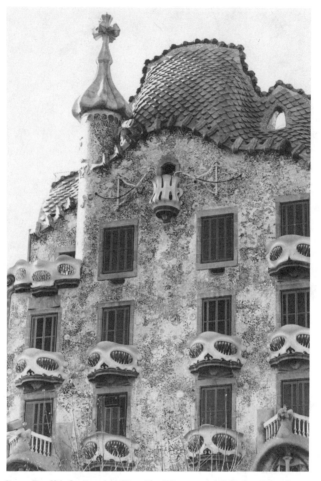

Casa Batlló design by Gaudí. (Courtesy Oficina Tècnica d'Imatge, Ajuntament de Barcelona)

able to the 1904–6 remodeling and reconstruction under the supervision of Gaudí in collaboration with his bright young assistant Josep Maria Jujol i Gibert (1879–1949) and his usual group of artisans for the decorative touches. To the popularly known "cases de los nuesos" Gaudí reworked all the exterior surfaces—front and rear façades, the roof, and the interiors of the ground floor, the principal floor, the stairwell, and the attics. The façade was cleaned in 1970. When Senyor and Senyora Batlló were shown Gaudí's plans for the remodeling, they approved the changes to his face but when alone the

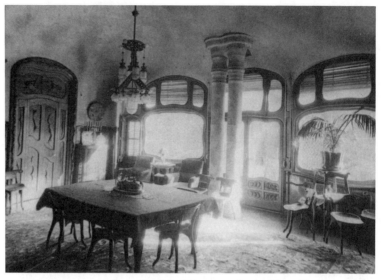

Dining room in Casa Batlló. (Courtesy Arxiu Mas, Ajuntamento de Barcelona)

couple confessed they did not really like what Gaudí had shown them.

As with the Casa Calvet, Gaudí also designed the entire interior, including all of the fixtures and furnishings. The total transformation of the house included the addition of a fifth floor as well as basements. Broken and discarded pieces of highly iridescent colored ceramic on the façade reflect a series of aqueous hues ranging from light blue to yellow, ochre, and white. It is easier to see the humpbacked, pierced roof profile from across the street. Only the top left-hand room was demolished in order to tie the structure architecturally and esthetically with Puig's Casa Amatller next door. The Casa Batlló is one of Gaudí's first buildings to incorporate large mosaic surfaces, which makes it one of the most charismatic houses in the area. British novelist Evelyn Waugh wrote in a 1930 copy of *Architectural Review* that he found the building so exotic that he mistook it for a part of the Turkish consulate in Barcelona.

Josep Maria Jujol, who was both a painter and an architect, frequently assisted Gaudí. The colored decoration of the façade of the Casa Batlló, the ironwork details, and the paintings in some of the first-floor rooms were the result of

this first major collaboration by Jujol with Gaudí. In his own distinctly unique Catalan designs, Jujol successfully solved the inherent problems when he blended both the competing and complementary Modernisme and Noucentisme styles.

Continue along this street to the next corner and turn left.

22. Design of Domènech
Carrer d'Aragó 255, Fundació Antoni Tàpies

Hours: Tuesday to Sunday: 11 A.M. to 8 P.M. Closed on Monday.

Other than the unusual brick exterior, the initial impression of this landmark building is the very large wire sculpture by Tàpies that appears to float above the roof. The foundation was created by the Catalan painter in 1984 to promote the study and understanding of modern art and culture. The establishment of both a museum and a specialized reference library in this historic building was the first step toward achieving these goals. Domènech initially created the magnificent building for the Editorial Montaner i Simón between 1880 and 1885. This is one of the best examples of the urban and architectural renewal of Barcelona during the Modernisme period. The restoration and modernization of the building for its present use was directed by Roser Amadó and Lluís Domènech, the son.

Today the museum presents exhibitions of modern and contemporary art from all over the world, and its permanent collection includes the world's finest and most complete collection of works by Tàpies, with masterpieces from every period of the artist's prolific production. The foundation sponsors lectures and conferences with international scholars and critics in order to contribute to a greater understanding of modern art and the culture it serves.

The library is an important research center on twentieth-century art, including not only extensive archives of published and unpublished material about its founder, who contributed his work, but also an exhaustive collection of works devoted to the art and culture of the Orient, reflecting Tàpies's interest in the presentation of non-Western cultures.

Continue to the broad divided Rambla de Catalunya and turn right. After one block, turn right again onto Carrer València for an interesting small side trip to number 24, the house another architectural Domènech—Joseph Domènech i

Estapá (1858–1917)—built for himself. As you double back to the Rambla de Catalunya and turn right, notice number 74, on the corner, which was also designed by this Domènech. Walk one more block to Carrer de Mallorca, turn right, and continue another block to the next site, on the corner to your left.

23. Design of Vilaseca
Carrer Mallorca 275 and Passeig de Gràcia 75, Casa Enric Batlló i Batlló

About the same time (1891–96) that Angel and Pia Batlló were building their large homes, Enric Batlló commissioned Vilaseca—the same who designed the Arc de Triomf (Walk 1, #22)—to construct his house. It was originally intended to be neo-Gothic style, but later renovations diminished the pure inspiration. Glazed balconies on each floor used to extend over the corner of Carrer Mallorca.

Turn left onto Passeig de Gràcia, proceed for one block, and cross to the far corner of the intersection.

24. Design of Gaudi
Passeig de Gràcia 92, Casa Milà or "La Pedrera"

Perhaps the most photographed and familiar of Gaudí's completed projects, the Casa Milà is considered the perfect culmination of Gaudí's previous experiments on other neighborhood houses. Undulating and lumbering around the commanding corner of Carrer de Provença, this may be the crown of Gaudí's secular designs. It is a six-story apartment building arranged around two connecting courtyards, one oval and the other circular. Upon entering through the huge glass-and-wrought-iron gates, notice the two circular ramps originally intended to allow cars access to the apartments. Due to space limitations imposed by the design, only these ramps that allowed entrance to the courtyard and basement stables were completed. You should also view this most popular and internationally famous residence from across the street in order to note the sculptural, even pictorial, forms of the façade and the "waved" roof. The dramatic forms of the interior and the exterior represent the two fundamental trends of the Modernisme school: expressionism added to the new rationalism made possible by the introduction of new machines and materials.

Casa Milà Gaudí's best-known structure. (Courtesy Oficina Tècnica d'Imatge, Ajuntament de Barcelona)

La Pedrera (the Quarry) was designed for don Rosario Segimon de Milà, a partner of Felio Batlló i Barrera in the textile business. A sculptured figure of the Virgin Mary was supposed to have adorned the top of the façade. When, amid other numerous delays and modifications, this was eliminated, Gaudí, in great disappointment, declared his work on the building finished and dissociated himself entirely from the project in 1910. However, his assistant Jujol continued to supervise the mainly decorative details, including the colorful frescoes by Clapés in the entrances and patios, until well into 1912.

In 1954, the step-down ground-floor rooms had their gratings removed to be converted to the present commercial shops. At the same time, the garret was remodeled into modern duplex apartments by architect F. J. Barba Corsini, but today the individual spaces are removed and the attic restored. Each residential unit is completely different because Gaudí designed them to be totally unique in floor plan and decoration.

The materials for the massive stone outer shell, which is completely separate from the underlying structure, came from Vilafranca, the capital of the nearby wine-growing re-

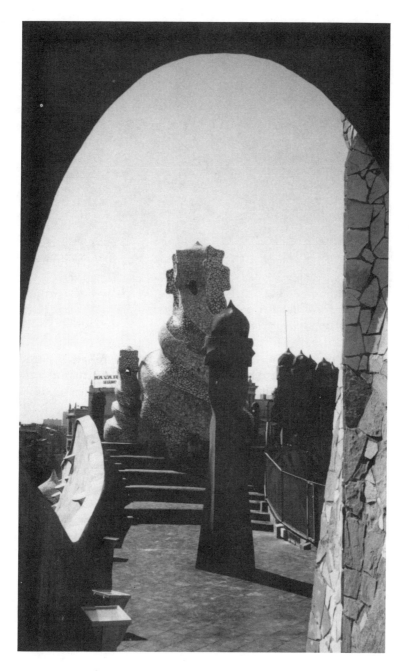

Roof, Casa Milà. (James Jordan Haight)

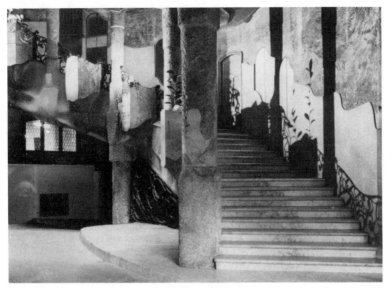

Interior courtyard, Casa Milà. (Courtesy Oficina Tècnica d'Imatge, Ajuntament de Barcelona)

gion of Penedés. A system of brick and stone pillars secured with trussed iron girders and beams supports the main structure. When Gaudí insisted that one of the supports extend onto the sidewalk like an "elephant's foot," the civil authorities were extremely agitated.

The façade is attached to the solid frame by metal tie rods. Look closely at the twisting iron balconies to see traces of the original paint. When looked at from a distance, the entire structure can be imagined as a petrified wave. References to the sea dominate throughout. Notably, the undulating roll of each individual floor, the seaweed strappings of the balcony details, the tide-marks of Jujol's plaster ceilings, and the hexagonal blue-green tiles that incorporate starfish shapes are all references to the ocean. Rusiñol once jokingly remarked that the Milà family should not have the traditional cats or dogs as pets in such a house; reptiles and toads would be more appropriate. According to Salvador Dalí:

> Gaudí has built one house from the forms of the sea, representing storm-tossed waves. Another house is made from the still water of a lake. This is no question of deceptive metaphors or fairy stories—these houses

actually exist, real buildings, real sculpture showing twilight reflections of clouds in water, by means of a huge crazy pointillistic mosaic, shining with many colors.

The rough but evenly abraded exterior finish which naturally traps the light and shadows of the day has been described as "skin erupting over the façade in a very fleshy way, even surrounded by hair and decorated by pock-marks, tattoos and varicose veins." This design displays Gaudí's belief that "the architect must not speak in vague forms like the ornamentalist, but more concretely—his language is geometry." The unusual design was recognized for its significance even before it was finished by being declared monumental in 1909! This proclamation exempted it from compliance to the current norms set by municipal ordinances. In 1911 the jury of the city council's architecture competition noted it as one of the best works completed in 1910, but it was disqualified because many of the finishing elements were missing at the time of consideration.

As Francesc Pujols (considered by Dalí to be the greatest Catalan author/philosopher) stated:

> The wind, the sun and the rain drawn out of heaven in answer to pleadings and prayers, working the stove at the command of time, are the only ones who can compare with the stone masons who roughen the stone at the command of Gaudí.

On the sidewalk in front notice the hexagonal blue-green tiles originally designed by Gaudí and Jujol for interior courtyard ceilings.

25. Design of Antoni Rovira i Rabassa
Passeig de Gràcia 94, Casa Josep Codina

Although primarily a municipal architect, in 1898 Rovira (1845–1919) designed this house after completing the neighboring one in 1894.

26. Design of Rovira
Passeig de Gràcia 96, Casa Ramón Casas

Over the polished brass entrance doors a plaque reads:

> L'Arca de Noe on the fiftieth anniversary of the death of Santiago Rusiñol. And with recognition and remembrance of his long years in this house.

On the wall next to the door, another plaque reads:
And glory to the good Catalan whose light adds to the
garden of ideas and enlightenment. To the brush and
the quill, to the wit and the laughter, with which the
life of Rusiñol made us happy.

Beyond the interesting decorative hallway of the main
floor was the residence of the respected portrait painter
Casas. For many years his good friend, writer and artist
Santiago Rusiñol, maintained a studio here where groups of
young artists gathered.

*Continue up the passeig and turn left onto Carrer de
Còrsega. Go to the end of the block and turn right onto
Rambla de Catalunya.*

As you walk, notice the huge Palau Robert, designed by
French architect Grandpierre, that wraps around the south
corner of Passeig de Gràcia and Carrer de Còrsega looking
onto the plaça. The large walled garden behind it extends
almost the total length of the block along Carrer de Còrsega
to Rambla de Catalunya.

27. Design of Puig
Rambla de Catalunya 126, Casa Serra

Casa Serra was transformed—or, as some feel, muti-
lated—by a restoration of the original larger house, built in
1903–8, that demolished all but the two remaining corner
wings and by other more recent additions. The remaining
portion of the older construction faces the Rambla de
Catalunya along this entire short block. In its time this was
one of the best examples of a single-family palace, with
considerable space for a garden along the Diagonal, then one
of the preferred residential avenues of the growing upper
class of Barcelona. In the Barcelona city council's annual
architecture competition of 1908, the house was named best
building constructed in 1907; but because the building was
incomplete Puig was not awarded the prize.

While supervising this construction, Puig was also in
charge of the Barcelona public works; in 1901, he had in-
stalled a new municipal drainage system.

*Turn right and proceed down Avinguda Diagonal for one
long block, then turn left at the Plaça de Joan Carles I.*

28. Design of Pere Falqués i Urpi
Passeig de Gràcia 113 and Carrer de la Riera de Sant Miquel 6, Casa Bonaventura Ferrer

Outstanding sculptural treatments are featured on the front and back of this house constructed in 1905–6 by Falqués (1850–1916). It is worth a walk around the corner to Carrer de la Riera de San Miquel to see the cylindrical tower that shoots up the entire vertical wall. It was remarkably unique for this period but is now considered typical of Falqués's work. This rear façade has the character of interior walls that are meant to be far more functional and thus not representative of other elaborate designs of this time.

Continue up the Passeig de Gràcia for one block and cross the street at the far end of the center island.

29. Design of Domènech i Montaner
Passeig de Gràcia 132, Casa Fuster

Consol Fabra de Fuster commissioned this mansion in 1908 to be built in a privileged spot at the top of the passeig on the edge of the Quadrat. It is conjectured that this dramatic view was reason enough for Domènech i Montaner to accept the commission. Although he lived until 1923, this house, on which his son Pere assisted, was among his final major works, along with the Hospital de la Santa Creu i de Sant Pau (Walk 4, #26) and his recently completed masterpiece, the Palau de la Música Catalana (Walk 2, #14). For the relatively short time of his active involvement in the architectural scene of Barcelona, Domènech i Montaner was considered by many to be the living embodiment of the Catalan spirit, a chieftain in combining social, political, and artistic expression by uniting a cultural front with support from the people.

The multicolored patterned brick exterior of this building displays Moorish influences meshed with classic column supports over the corner entrance and on the second-floor balconies. A lofty tower reflective of Domènech's admiration of Arabic, or Mudejar, architecture originally soared above the corner. The interior has been entirely remodeled and, in 1963, only a student protest saved this special structure from the wrecking ball.

Continue back down this side of the passeig.

30. Home of Espriv i Castello
Passeig de Gràcia 118

The much-heralded Catalan poet Espriv i Castello lived in this building from 1913 to 1985. At the Palau de la Música Catalana, in October 1990, a requiem with full orchestra and chorus was presented in his honor. Note the plaque placed on the wall.

31. Design of Eduard Ferrés i Puig
Passeig de Gràcia 114, Casa Lluís Ferrer-Vidal

Noteworthy about this house is its construction of reinforced concrete. The company of contractor J. Miró i Trepat was the first in Barcelona to utilize this material. Built in 1914–16 at the conclusion of the blooming era of Modernisme, there is the classic downplaying of decoration in the hallway of the house as designs became simplified. The original roof had crowning features that were spoiled by the addition of both the extra floor and a dome, now removed. Looking closely on the front wall, you can see the name of the architect, Ferrés (1880–1928).

32. Design of Sagnier
Passeig de Gràcia 112, Casa Rupert
Garriga o Garriga Noques

This is another Moderniste home much reconstructed and modified, especially in its hallway, which lacks any kind of decoration. The remarkably plain stone façade is also typical of the conclusion of the Modernisme years. Two additional floors have been added to the original ground level, and the upper four floors and a balcony formerly over the ground floor have been removed.

You can cross the Diagonal to the Metro Diagonal here. Or, if you wish, you can lunch at one of several cafés in the area and then head northeast on Carrer de Còrsega to the first site on Walk Four.

WALK

THE ELEGANT EIXAMPLE

FOUR

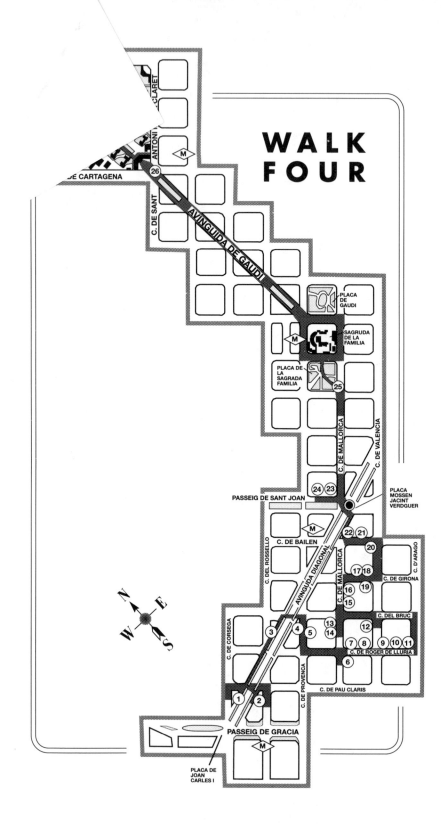

WALK
FOUR

Metro Diagonal

> What is architecture? Surely the crystallized expression of
> man's noblest thoughts, of his ardour, his human nature,
> his faith, his religion.
>
> Walter Gropius

In the initial part of the twentieth century, bourgeois
residents moved to small palaces and apartment houses on
the slopes of the gentle hills surrounding Barcelona. The
network of trams and trolleys, electrified in 1900, played a
very relevant role in the move to the upper part of the city.

This walk takes you on the tree-shaded residential streets
lined by smart and still much-desired apartments, then con-
cludes with the crown jewels of the work of Domènech (a
hospital) and Gaudí (a cathedral).

*Exit the Metro at the Plaça de Joan Carles I and walk
northeast on the Carrer de Còrsega to the corner of Carrer de
Pau Claris.*

**1. Design of Salvador Valeri i Pupurull
Carrer de Còrsega 316 and Avinguda
Diagonal 442, Casa Comalat**

The front side of this building reveals why it is a prime
example of decorative modernism. It is alive with textures,
colors, shapes, moldings, and reliefs in fantasy shapes. Un-
fortunately for us, the greatest decorations are in the interior
hallways. The two different street façades represent the
attempt by the architect to have both an interior as well as an
exterior equally visible at street-level view. The Còrsega
street façade represents an image usually found in the inte-
riors of Moderniste structures within the Eixample. Here,
Valeri (1873–1954) attempted to freely express his imagina-
tive treatment of the usual elements of late Modernisme-
rational façades. Also note that the house is elevated at one
side.

*To see the rear of this building, turn right at the corner
and follow Carrer de Pau Claris for one short block, then turn
right around the next corner onto the Diagonal. Then, to
move on to the next site, directly across the street from the rear
façade, cross Avinguda Diagonal at its intersection with
Carrer de Pau Claris and turn right to the middle of the block.*

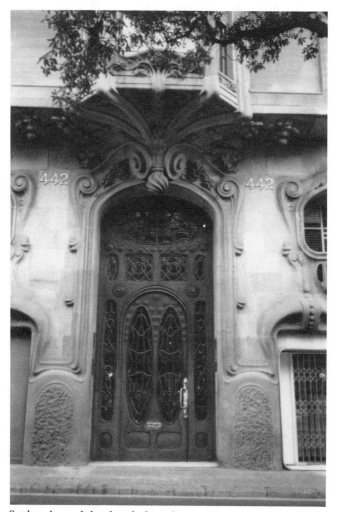

Sculpted wood, lead and glass door at Casa Comalat. (Mary Ellen Jordan Haight)

2. Design of Puig
Avinguda Diagonal 373 and Carrer del Rossellóo 279, Palau Baro de Quadras, Museu de la Música

Hours: Tours from 9A.M. to 2P.M.

Built in 1902 for the Baron of Quadras, this building holds a diverse collection of musical instruments, including one of the more complete and extensive assemblages of guitars in

Europe. Puig's first architectural period was the "pink," or "nostalgic," represented by his generous use of brick in his designs. In this example of his second, or "white," period, also referred to as his "civilized period," he used stucco and exposed stone frames around windows and doors. The final period has been called his "yellow," or "plutocratic," period, in which he did pieces in a monumental classic style. Oddly, the periods are not chronological, as with other architects or artists (Picasso, for instance, whose blue period was distinct from his pink period which followed), and thus may be considered to be more styles rather than classic periods.

The present-day appearance of the palau is radically different from the original reconstructed countenance by Puig. Due to the narrowness of the block it is possible to view the two façades, which in this case clearly show the restoration and reformation of the original building. The Diagonal street side has the design typical of a noble's house of the Gothic age, with the appearance of a palace for a single family. The Carrer del Rosselló façade was also modified in Puig's reconstruction but, interestingly, has the usual incidences of a multifamily dwelling.

Retrace your steps to the corner, cross Avinguda Diagonal, and continue in the same direction along it for just over one block.

3. Design of Puig
Avinguda Diagonal 416–20, Casa Terrades or Casa de les Punxes

The Casa de les Punxes, built between 1903 and 1905, also known as the Casa Terrades, has been designated as Puig's finest structure. It is located on this island of land because the Barcelona city planner, Ildefons Cerdà (1815–1876), who redesigned the city in the mid- to late nineteenth century, sliced some blocks into islands with the Diagonal when he prepared the survey of 1855. Puig's structure is a medieval-inspired apartment building with steep gabled roofs articulated at each corner by a cylindrical tower and steeple. Walk entirely around the whole block to find the three beautiful entrances with brass details, door knockers, and intricate work displayed throughout the entrance halls.

The irregular site was owned by the three sisters of the Terrades family—Angela, Josefa, and Rosa. The architect

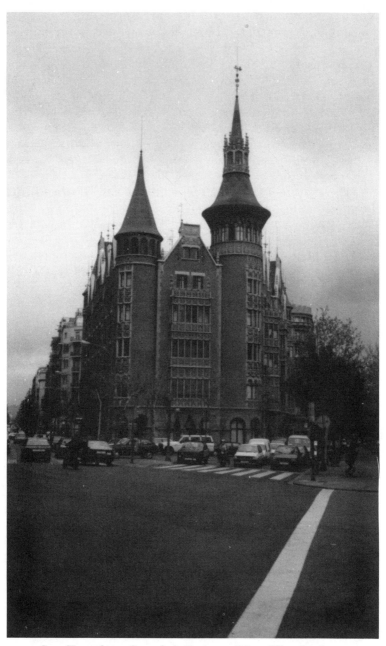

Casa Terrades o Casa de la Punxes. (Mary Ellen Jordan Haight)

planned the building's exterior to appear as a single large unit that encompassed three independent houses, a novel idea at the time for a multifamily dwelling. It is one of the largest singular structures of its time in terms of exterior walling and floor space, and it was favorably mentioned in the Barcelona city council's 1905 competition as one of the best buildings completed in 1904.

Cross Avinguda Diagonal at Carrer del Bruc to the next site.

4. Design of Gabriel Borrell i Cardona
Avinguda Diagonal 355 and Carrer de Provença 301, Casa Pilar Bassols

Another good example of late Moderniste architecture, this house was built in 1914–16. Look for the differing treatments in the two exteriors facing on the two converging streets. The main façade on Avinguda Diagonal is completely composed of stone, but the rear was considered to be a less important address and so is more simple, with less detailing on freestone-imitation stucco.

Round the corner onto Carrer de Provença to see the rear, then cross the street.

5. Design of Arnau Calvet i Payronill
Carrer de Provença 324–326, Cases Francesc Lalanne

The adjoining houses by Calvet (1875–1956) on the property owned by Lalanne look similar but are actually different widths because of the variant dimensions of the lot. Both were built in 1906–11.

Heading away from the Diagonal, turn left at the next corner and go down Carrer Roger de Llúria for one block, then cross to the far corner of the intersection.

6. Design of Domènech i Estapà
Carrer de Mallorca 278, Palau Ramón de Montaner

Early in the Modernisme era, 1889–93, Domènech i Estapà was commissioned to design and supervise the construction of two small palaces for the publishers Montaner and Simon. A block of houses had formerly stood here. The palace built for Simon by Domènech i Estapà was completed and furnished by Gaspar; it no longer exists. The present

structure was built for Ramón de Montaner with original plans drawn by Domènech i Estapà; but, because of their disagreements, the owner hired Lluís Domènech i Montaner to complete the work. This palace is rare because very few preserved examples of the early large houses situated in the Eixample can be seen today.

Continue down Carrer Roger de Llúria.

7. Design of Jeroni F. Granell i Manresa
Carrer Roger de Llúria 84, Casa Jeroni F. Granell

Granell (1867–1931), the architect and owner of this apartment building (1899), also created some of its stained-glass windows. It was mistakenly known for years as the Casa Jacinta Maristany.

8. Design of Granell and Domènec Boada i Piera
Carrer Roger de Llúria 82 and Carrer de València 285, Casa Jaume Forn

Wrapping around the corner is the Casa Forn, built in 1904–9. Though the architect Granell was the stated owner when the initial construction papers were filed with the city, before actual construction began Jaume Forn became the new proprietor and Granell was replaced by Domènec Boada i Piera (1865–1947). Note the extraordinary angular stained-glass windows.

9. Design of Juli Fossas i Martínez
Carrer Roger de Llúria 80 and Carrer de València 312, Casa Castillo Villanueva

This building by Fossas (1868–1945) initially had two symmetrical towers, each with glazed corner balconies. The removal of one of the towers and one of its glazed balconies disfigured the exterior for, as we face it, it seems unbalanced. The house was owned by the children of Castillo Villanueva, Ferran and M. Teresa Villanueva.

10. Design of Isidre Raventos i Amiguet
Carrer Roger de Llúria 74, Casa Agustí Anglora

The master builder, Raventos (1849–1911), like others of the day, produced a high level of quality construction in the

Eixample. It was the sum total of many minor projects, such as this house (1904–6) that gave character and quality to the new central district of Barcelona.

11. Design of Salvado Viñals i Sabaté
Carrer Roger de Llúria 72, Casa Pere Salisachs

The façade by Viñals (1847–1926) is quite typical of others built early in the twentieth century. The iron balconies are similar to those used by Sagnier in the Casa Camil Mulleras (Walk 3, #5), and the glazed balconies and cornices resemble those designed by Barneys for Casa Puig (this walk, #16). Observe the family's initials above the entrance that is flanked on both sides by plaster likenesses of the first owners, Senyor and Senyora Salisachs. Looking through the door, you can see the highly romantic pastel-painted ceiling fresco.

Turn left at the next corner, then after one full block turn left again onto Carrer del Bruc. Continue for another block and turn left again to the next site, about fifteen yards away.

12. Design of Miguel Madorell i Ruis
Carrer de València 293, Casa Pau Ubarri

Above the entrance door of this building—designed by Madorell (1896–1936), originally a private home but now given over to apartments—is the coat of arms of the owner, the Count of San José de Santurce. The building itself, appropriately, is topped by two singular towers above a series of glazed balconies.

Backtrack up Carrer de València, turn left on Carrer del Bruc, then left again at Carrer de Mallorca.

13. Design of Antoni Millàs i Figuerola and Josep Maria Jujol
Carrer de Mallorca 284, Casa Francesc Farreras

Although the initial architectural plans were signed by Domènech i Montaner, this design is actually attributed to Millàs. In 1913 the owner, Josep M. Iglesias, hired Jujol to design the original elevator, one of the most outstanding singular works to be found in the Eixample. Jujol's graphic, colored stucco ornamentations are so extreme that they are unmistakable. Many critics believe that Jujol deserves greater credit for extending what were then the normal limits of architectural detail in decoration.

14. Design of Domènech i Montaner
Carrer de Mallorca 291–293, Casa Thomas

In the original construction of 1895 only the ground-floor workshops and the first floor of the J. Thomas dwelling existed. The upper floors were completed in 1912 by his heirs. The towers you see above the top floor were rebuilt from the original two-story structure, but the glazed balconies were added in a later reconstruction of 1922. Note the columns along the façade on the fifth floor; these were originally located on the second floor.

Cross to the other side of Carrer de Mallorca and backtrack.

15. Design of Josep Barenys i Gambus
Carrer de Mallorca 302–304, Casa Dolors Xiró vda. de Vallet

Barenys (1875–1915) began construction on the first of these adjoining apartment buildings in 1912 and a year later erected the building next door. The types of balconies–colored tile balconies–and the unusual mezzanine floors are characteristic of many other projects Barenys directed for the Vallet i Xiró family. The oval windows in the mezzanine reflect influences of the Viennese Secession movement in Austria.

16. Design of Barenys
Carrer de Mallorca 306, Casa Carme Carsi de Puig

At the same time (1912–15) Barenys was creating this third house. Again we see the iron balustrades for the balconies and one central oval window. His repetition of patterns of the individual items on all of his building designs demonstrates his collaboration with the same industrialists in his use of manufactured elements. The original house did not include the dissimilar plain top floor.

Turn right at the next corner.

17. Design of Granell
Carrer de Girona 122, Casa Jeroni F. Granell

Not only was Granell again the owner and architect of this apartment house (1901–3), but he acted as the contractor and his successful firm, Rigalt i Granell, executed the stained-glass windows. This building is somewhat unique for a Moderniste design in the Eixample because from the begin-

ning it was meant to contain multiple apartment units. The colorful sea-foam green relief decorating the façade only slightly indicates the adornment scheme of the interior floors. From the main floor to the top, the garnishes are unusually plain for a structure of this era.

18. Design and home of Adolf Ruiz i Casamitjana
Carrer de Girona 120, Casa Adolf Ruiz

Next door, Ruiz (1869–1937) designed and built his own house. Initially he conceived it for a more narrow piece of property, but halfway through construction he added an adjoining piece of property and the dimensions of the rectangular brick building were increased so that it appeared more conventional in size and appearance. Though the date 1909 appears on the exterior as the date of completion, records show that it was actually finished in 1903.

19. Design of Domènech i Montaner
Carrer de Girona 113, Casa Llamadrid

This property was occupied by a single-story dwelling with a garden until 1902, when Domènech i Montaner was commissioned to design the present structure. Considered by some architectural scholars to be his first modern design, it is also his most interesting. As well as being an architect, Domènech i Montaner was a member of the Spanish Parliament, a powerful representative from Catalunya responsible for building the strong sociopolitical movement that marked the beginning of the struggle for autonomy for Catalunya. Initially granted in 1931, this independence was short-lived because of the violent fighting in the ensuing Spanish civil war.

Turn left at the next corner and proceed for one block.

20. Design of Antoni Gallissa i Soqué
Carrer de València 339 and Carrer de Bailèn 113, Casa Manuel Llopis

This majestic corner building was started in 1902 by Gallissa (1861–1903) and completed the next year in collaboration with Gaudí's former assistant Jujol. Possibly the most important of Gallissa's designs, it best demonstrates his notable knowledge of the building and construction trades. Evident throughout the structure is his use of decorative details, most notably the glazed and open balconies and the

connection of the ground floor to the whole structure. Slight modifications have been made to the three towers and the brightly tiled central balcony.

Once you have rounded the corner to see both faces of the building, continue your stroll up Carrer de Bailèn toward the Diagonal.

21. Design of Granell
Carrer de Bailèn 126, Casa Rossend Capellades

Another of the prolific Granell's projects—although the plans were signed by the master builder Josep Graner i Prat—this was built in 1904–6. The façades of this and Granell's other apartment house at number 127 across the street depart from the usual appearance of multiple family houses, especially in the application of the stone.

Continue to the large intersection of three streets just ahead.

22. Design of Jujol
Avenue Diagonal 332, Casa Planelles

The Casa Planelles was designed by this talented understudy of Gaudí in 1924 and is considered a classic juxtaposition of geometrical systems. A curvilinear façade was added to the conventional structural supporting walls. It is this sort of innovative architectural statement by Jujol, in large part possible because of the advent of new industrial-age construction techniques and materials, that sets him apart from his mentor. Critics of this architectural period have said that Jujol's works "battle themselves," the composition of a structure at times destroying its own function.

The original design proposed by Jujol was a statue portraying the Immaculate Conception standing on a colossal pedestal which, in fact, was the house. Evidently the client, Eveli Planelles, himself a builder, could not see living in a religious monument reflecting Jujol's deep religious feelings. Eventually, architect and client settled on the present design reminiscent of a smaller Casa Milà. The building undulates on a miniature scale around the intersection of three large streets. A look through the iron-criss-crossed glass entrance door reveals a circular stairway enclosed by a fanciful metal banister and decorative stucco pillars and ceiling.

Walk to the right on Avinguda Diagonal to Passeig de Sant Joan, cross the parklike street to the far corner of the intersection, and walk to the left.

23. Design of Puig
Passeig de Sant Joan 108, Casa Macaya, Seu del Centre Cultural de la Caixa de Pensions

As often happened with Puig's other works, the façade and the layout of the ground floor of this well-known building (1901–2) were originally designed as a single-family dwelling but were later altered. Many of the elements of the interior decoration have not been preserved. Exceptions include the hallway tiles by Bausís, wall garnishes by Paradís, and the lovely whitewashed patio, now roofed over for an atrium, with an unusual covered staircase. This alabaster stucco building is beautifully restored with interior Moorish influences and refurbished stained glass. Now a cultural center, the gallery holds frequent art exhibits.

24. Design of Enric Fatjó i Torras
Passeig de Sant Joan 110, Casa Dolors Alesan de Gibert

This design of Fatjó (1862–1907), built between 1902 and 1905, went relatively unnoticed in the central Eixample because the exterior could not compete with the nearby structures of greater quality, such as the next-door Casa Macaya. The most noteworthy element here is the exceptional quality of the finish on the façade that now makes it one of the beauties of the area.

Backtrack down Passeig de Sant Joan toward Avinguda Diagonal, but when you reach the intersection turn an immediate left onto Carrer de Mallorca. Move toward the gigantic spires you will see several blocks in the distance.

25. Design of Gaudí
Carrer de Mallorca 401, Temple de la Sagrada Família and Escoles Parròquials

Hours: 9 A.M. to 7 P.M.

Described by George Orwell in *Homage to Catalonia* (1938) as "hideous," the Church of the Holy Family, more than any other structure in Barcelona, is associated with Gaudí and his mystical, fantastical vision. The great American architect Louis Sullivan disagreed with Orwell and called it "the greatest piece of creative architecture in the last twenty-five years. It is spirit symbolised in stone!"

The original architect for this neo-Gothic project was the

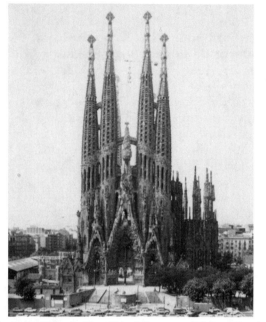

Temple de la Sagrada Família. (Courtesy Oficina Tècnica d'Imatge, Ajuntament de Barcelona)

Catholic diocesan architect Francisco de Paula del Vilar y Lozano; but in 1883, when the excavations for the crypt were completed, the thirty-one-year-old Gaudí was commissioned to continue the work. He was to devote his final forty-three years to his enormous vision, very little of which has been achieved. Perhaps Gaudí heeded the words of John Ruskin: "It is not the church we want, but the sacrifice, not the gift but the giving." The crypt itself was constructed between 1882 and 1891, and the vaulting was completed in 1887. On 19 March 1885, the first mass was celebrated in the Chapel of San José inside the crypt, two years before its completion. After a disastrous fire in July 1936 gutted the crypt, it was fully restored. From 1891 to 1930, work continued on the towers and four spires.

The dominant aspect of the whole concept for the cathedral was the emphasis on verticality, the linking of heaven to earth. Gaudí meant it to tower over everything in sight; it is taller than St. Peter's Basilica in Rome. In fact, many of the church's leaders opposed Gaudí's plan because of its unusual style and because they felt that the mammoth size of it would

Temple de la Sagrada Família with parochial school in foreground. (Courtesy Archive Càtedra Gaudí)

overwhelm the city's Gothic cathedral. Like the European medieval cathedrals, Gaudí knew it would never be completed in his lifetime and he is reported to have said, "My client is in no rush." His dedication to the project was such that, for the last fifteen years of his life, he accepted no new commissions and even moved into a studio-workshop on the temple site. He so fervently devoted himself to soliciting funds to continue the work that, it is said, people crossed to the other side of the street when they saw him approaching.

Due to Gaudí's disinterest in the physical appearances of success and fame, when he was fatally injured on the Gran Via by a trolley bus in 1926 while on his way to his habitual morning prayers, he was mistaken for a tramp and died in a pauper's bed at the old Hospital de la Santa Creu. His most ambitious work was only a quarter finished when he died; today, almost three-quarters of a century later, it is still incomplete. By special dispensation, Gaudí was buried here on 12 June 1926. After his death, work continued under a group of close collaborators; but because of the coming civil war, in 1935 construction halted. During the ensuing violence fire

gutted part of the building, and the models and plans in Gaudí's studio were destroyed. Work began again in 1952 and continues with financing from admission fees and public contributions. Under the direction of Jordi Bonet, whose architect father had studied under Gaudí, and amid much controversy, a team of architects plans to finish the nave in 1993. According to Edward Schumacher, the heart of the dispute lies in two vexing questions: Is an architect an artist? and is his work inviolate? Supporters of the project say Gaudí expected his church to be finished and functional. Critics maintain that because Gaudí's original plans were destroyed in the civil war the present work is based on conjecture and is destroying the integrity of an artistic treasure. "It's impossible to replicate Gaudí's spirit," said Daniel Giralt-Miracle, director of Barcelona's Museu d'Art Modern.

The Sagrada Família is perhaps the most remarkable and unusual religious structure to have been conceived during that last hundred years. It not only reflects the work of the ongoing international modern art movement, but it may even be said to have foreshadowed the expressionist style of the early twentieth century.

The parochial school was dedicated in November 1909 and was restored twice by the architect Francesc de Paula Quintana after it was also destroyed by fires during the civil war. The school represents a good example of Gaudí's imaginative use of the Catalan vault, an extremely ancient form of construction possibly dating back to before the Moorish invasions of Spain. Because of budget constraints, Gaudí chose a flat-type solera vault composed of three layers of thin, broad tiles bound over each other and laid on a conoidal surface with supporting rafters and a central steel I-beam running down the main space of the school. Likewise, the walls are made of the same materials.

Head north on Avinguda de Gaudí, which angles off the north corner of the block on which the temple stands.

26. Design by Domènech
Carrer de Sant Antoni Maria Claret, Hospital de la Santa Creu i de Sant Pau

As with Gaudí's design for the Sagrada Família, Domènech i Montaner's extraordinarily original plan for a hospital and its exterior decorations make for a noteworthy

visit. The difference between Gaudí and Domènech i Montaner, according to César Martinell, is that Domènech decorated his columns with spiral forms but Gaudí conceived his columns as spirals. The Hospital de Sant Pau was built during the years 1902–10 and is now combined with the successor to the fifteenth-century charity Hospital de la Santa Creu. The design for a hospital during this age presented a philosophical and thus architectural challenge for Domènech, who considered the usual single large medical institution to be inhumane. His original solution to this problem was a layout that spread the medical services to patients in many smaller clinic buildings set on four city blocks. The traditional monolithic hospitals were supposedly efficient in an age that predated computers; so, to overcome the technical difficulties of communication caused by his unconventional plan of scattered pavilions, he devised an effective information system by means of underground tunnels. Each pavilion and independent annex preserved personal humane contact between the institution and the patient—the fundamental goal of the architect. The hospital has since been called everything from traditional to "archaeologistic."

Domènech's passionate interest in reviving and revitalizing the Catalan crafts and techniques is reflected in the patterned brick exterior decorated in bright ceramics and unusual multicolored pictoral mosaics.

Enter the primary building, which is straight through the imposing iron entrance gates. Exit at the opposite side of the vaulted hall, and on the exterior wall you will see a mosaic mural by Maragliano of a large painting by Larbata. Follow the road around the incline lined by various special-purpose buildings adorned with brightly colored stones and tiles. The benches scattered around the verdant gardens are an invitation to linger before heading for the Metro Hospital de Sant Pau a block to your left from the main entrance down Carrer de Cartagena to Carrer de la Indústria. Or, if it is meal or coffee time, we can recommend the cafés you passed on the Avinguda de Gaudí.

WALK FIVE

THE URBAN GARDEN

WALK FIVE

PARK GUELL

③ MUSEU GAUDI

② C. D'OLOT

C. DE MERCEDES

RAMBLA DE MERCEDES

AVINGUDA
SANTUARI DE
SANT JOSEP DE
LA MUNTANYA

PTGE. DE
MERCEDES

C. DE LLARRARD

HOSPITAL DE
L'ESPERANCA

C. DE LA MARE

TRAVESSERA
DE DALT

TRAVESSERA
DE DALT

PLACA
DE
LESSEPS

Ⓜ

C. SANTA PERPETUA

PRINCEP D'ASTURIES

C. GRAN DE GRACIA

C. LES CAROLINES ①

Ⓜ

W N E S

Metro Fontana

Upon exiting the Metro, head north on the Carrer Gran de Gràcia, turn left at the first street—Carrer les Carolines—and walk about seventy-five yards.

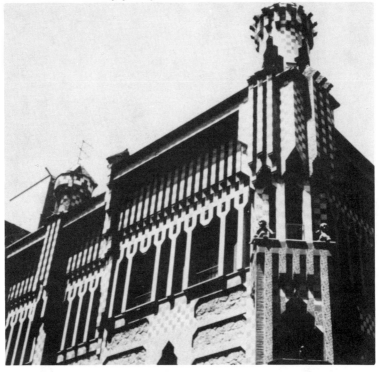

Casa Vicens. (Courtesy Oficina Tècnica d'Imatge, Ajuntament de Barcelona)

1. Design by Gaudí
Carrer les Carolines 24–26, Casa Vicens

Very early in Gaudí's career (1883–85), Don Manuel Vicens, a ceramic and tile manufacturer, commissioned him to design a suburban villa. The lot was not large, so Gaudí chose to emphasize height by making the verticals of the chimneys continue down the façade and by using an irregular roof configuration emphasized by turrets. The original garden has been reduced by a more recent widening of the street, but the house is twice its original size due to alterations by a subsequent owner. The richly studded exterior of rubble stone and pink brick is checked with floral ceramic

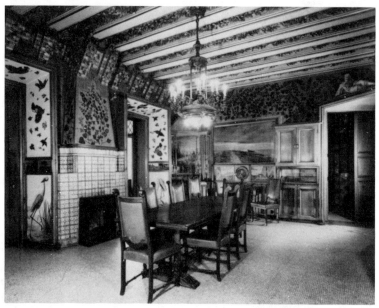

Dining room of Casa Vicens. (Courtesy archive of Catedra Gaudí, Barcelona)

girdles. The lines of the building are sharp and well-defined. Perhaps the most famous detail of the house is the jagged wrought-and-cast-iron railing with a design repeated in the real palm trees planted in the garden and the imprinted palms on the small domes of the balconies.

The interior has richly and elaborately carved and molded surfaces in the otherwise conventionally organized individual rooms. Gaudí's joyful enthusiasm is evident in the dining room, in which he created an artificial aviary and greenhouse by painting panels of flying birds and pink and red carnations on small corbels (supported projections from the wall) near the ceiling. The spaces between the wooden beams of the ceiling are adorned with colored plaster clusters of berries, fruits, and leaves. Moorish influences can be seen in the design of the twelve-foot-wide "fumoir" (smoking room). Walls lined with ceramic and heavily embossed papier mâché tiles, and a low honeycombed ceiling from which hangs a glass lantern decorated with blue Arabic figures, lend a serious Moorish richness to the room. For Gaudí, as for the American architect Frank Lloyd Wright, an architect and his

designs were all inextricably wedded to the environment out
of which they came and in which they were to operate. The
Vicens house clearly represents the freedom Gaudí infused
into his early designs along with his fierce Catalan national-
ism and a bit of his creative humor. His work elicits from the
viewer both respect and enjoyment. Three beliefs sustained
Gaudí's philosophy of life: the belief in a Christian God, the
belief in Catalunya, and the belief in architecture as ex-
pressed in this quote:

> Whoever wants to make true architecture has not only
> to possess remarkable skill but has to exert himself as
> if he were trying to climb a high mountain; he must
> know his strength and be prepared for discipline and
> even for sacrifice—which are indispensable for the ac-
> complishment of such a lofty goal.

*Return to Carrer Gran de Gràcia and walk north to the
Plaça de Lesseps and through its gardens to the opposite cor-
ner, where Travessera de Dalt begins. Take this broad street
east for about six blocks to Carrer de Llarrard, then turn left
up Monte Carmelo—or "Montana Pelada," which literally
means "Bald Hill"—to the park entrance.*

2. Design of Gaudi
Carrer D'Olat, Park Güell

The ornate iron entrance gates of the park were first
designed by Gaudí as fencing for the Casa Vicens. Observe
the curved, peeling boundary wall, decorated with alternat-
ing ceramic medallions spelling "Parc" and "Güell." In 1900
Gaudí's patron, Count Eusebio Güell (a year later he estab-
lished a Portland cement company in Spain), decided that
thirty-eight acres of the family property possessing spectacu-
lar views of the city stretched out below should be developed
into an English-style garden residential suburb with atten-
dant services in buildings clustered around the main gate.
Sixty lots were defined for development and were accessed
by sinuous roads that climbed the slopes. Only two houses
were completed: one, built for the Güells, was occupied by
Gaudí's friend and physician Dr. Alphonso Trias; the other,
designed by Francesc Berenguer as the original show house,
was Gaudí's residence from 1906 until his death in 1926. In
1922, due to the failure of the project, the land was acquired
by the municipality. Ironically, the middle class for whom the

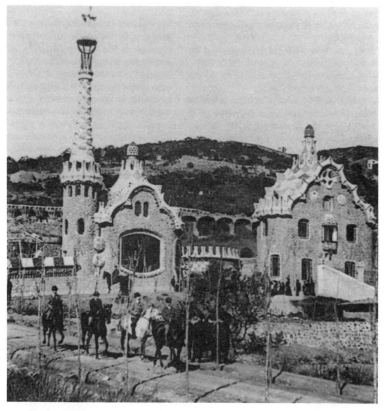

*Early photograph of the pavilions by the entrance to Park Güell.
(Courtesy Archive, Càtedra Gaudí)*

suburb was intended was resistant to "estate living," as well as cautious of moving to what was then an unfashionable area so far from the central city. It was opened as a community park and survives today as a tribute to Gaudí's sensitive collaboration with nature.

Flanking the main entrance are two buildings with elaborate polychrome roofs. The one on the right houses a gatekeeper and the other holds such essential services as restrooms, telephones, simple refreshments, and a shop selling postcards, books, and posters. The twisting spire topping the building is crowned with a cross and is distinguished because it is one of the first examples in Spain of reinforced construction. The supporting metal columns are often seen

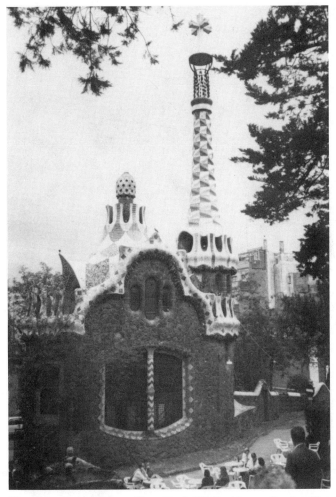

Closeup of entrance pavilion, Park Güell. (James Jordan Haight)

in Gaudí's work. About the column, and its relationship to the other major architectural elements of a structure, Gaudí remarked:

> The column is like the shaft, the trunk of a tree; the roof is like the mountain with its ridge and slopes; the vault is the cave of parabolic section; the more resistant terraces of the mountain cliff form lintels and corbels over places where the weaker strata have eroded away.

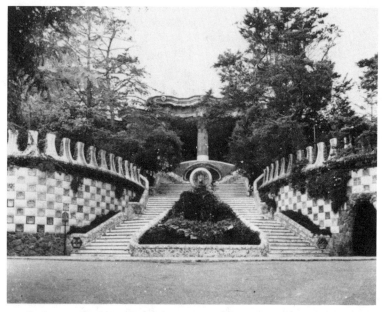

Staircase, Park Güell. (Courtesy archive of Catedra Gaudí)

A double flight of steps with ceramic banisters ascends past various ceramic decorations to the Room of a Hundred Columns (eighty-six, actually), or market hall, which contains the original ceiling and benches that were decorated with tile fragments collected by Gaudí. The classic Gaudí eye for practical detail is reflected in his design of the idiosyncratic doric columns: each has a hollow central core that is used for drainage. Water is conducted through them to a cistern at the back of the hall, where it was to have been stored for use by the planned community.

Side stairs lead from the colonnade to an open-air arena and terrace above, which was originally intended for theatrical events but is now used mostly by young people for every sort of sporting activity. The notable feature of this field is the ceramic bench—said to be the longest in the world—that undulates around its circumference. The surface was finished by Josep Jujol, who meticulously broke and jigsawed the ceramic coating over the warped uneven face. Look for the animal symbols, letters, numbers, and disassociated words with religious meanings incorporated in the ceramic border. Here is an example of Jujol as the transitory artist who divided his career between architecture, sculpture, the decorative arts, and drawing. Not only was he appointed a lecturer

in the School of Architecture, but also in the School of Arts and Crafts at the Industrial University.

Climb the path that stays to the natural contours of the ground to the first house.

3. Museu Gaudí

Hours: 10 A.M. to 2 P.M. and 4 to 7 P.M. Monday-Friday; closes at 6 P.M. Sunday and bank holidays. Closed on Saturdays.

Gaudí's residence is now a museum filled with his memorabilia and furnishings. In 1936 this house was declared a national monument, and it is now managed by the Amics de Gaudí, an organization formed in 1963 to preserve the memory and works of Gaudí.

Upon entering the tiled ground floor, note the 1913 portrait of Gaudí's patron Count Güell by Julio Moises and the unusual iron coatrack designed by Gaudí between 1898 and 1904. The dining room, Sala Battló, contains a modern, blond-wood carved table and chairs and a 1904 mirror in a curved wood frame. A winding black-and-mauve marbled staircase in the front hall climbs to the first-floor main salon and Gaudí's office and bedroom. Among the furniture in this area is a remarkably detailed, highly varnished and polished center table by Jujol, inlaid with wood and a bay scene in gold. The wrought-iron ceiling lamp in the center hallway was designed by the building's architect, Berenguer. A mirror and sideboard are undated, and paintings by Aléjo Clapés along with drawings by Jujol hang on the plastered walls. Set on a platform is a fully restored chaise longue created by Gaudí in 1888. In the bedroom, Gaudí's narrow single bed faces a silk portrait of Pope Pius X. An absolute faith in the Catholic religion, according to Gaudí's intimate friend Francesc Pujols, gave him perfect balance, "his own narrow mold, adopted to himself alone, which his genius had been awaiting in order to embody it even more, to descend to further depths, to suffer even more, to arise in even greater splendor." Next door, a red-stained mahogany work table, built around 1890, that once belonged to Gaudí's professor, Josep Vilaseca, holds a 1900-era typewriter. The standing clothes closet was initially designed by Gaudí for the Casa Milà. When examining the exterior of the building, note the wonder of red, yellow, and blue tiles on the chimney of what was formerly the kitchen.

To reach the highest point in the park, where a chapel in the shape of a rose was planned to be built but which is now marked only by three stone crosses, take one of the main paths that run on top of four stretches of arcades and viaducts supported by tilted columns. The interior of the arcades feels like a cool underground grotto, and they provide protection from the sun and rain. From every point in the park, the natural lush landscaping frames views of Barcelona and the sea below.

In keeping with its countrylike setting, there is no Metro station nearer the park than the one where you began this walk. When you are ready to leave, you can most often catch a cab at the park entrance.

Museu Gaudí at Park Güell. (James Jordan Haight)

WALK

THE
MONTJUIC
PANORAMA

SIX

Metro Tarragona

As you exit the Metro and head southeast on Carrer de Tarragona, you will immediately see a large towerlike sculpture on your left.

1. Carrer de Tarragona and Carrer d'Argo, Parc Joan Miró

In the center of an enormous esplanade is an ornamental lake. The towering sculpture set in the water was entitled by Miró *Dona i Ocell.*

Miró first met Picasso in 1917 at a performance in Barcelona of Diaghilev's Ballets Russes. The next year, Miró was finally able to follow the earlier Catalan artists to Paris, where the older and already renowned Picasso encouraged him. Although he was conservative in his style and subjects, as seen in his detailed and orderly images of life on his father's farm (the cult of the parental farmhouse as the model of Catalan society), in Paris he was influenced by his surrealist friends. Miró's paintings of brightly colored surrealist figures were the products of these years with the rue Blomet group of artists. The French surrealist author André Breton said that "it can be held that Miró had a largely determining influence on Picasso." Picasso never admitted this debt, but his 1926–28 paintings resemble the fantasy of Miró's little figures suspended in midair.

Just ahead is the Plaça de Toros les Arenes, the red-brick bull ring, on your route to the huge and imposing Plaça d'Espanya. The monumental fountain in the center of the plaza was designed by Josep Jujol in 1928 for the 1929 International Exhibition of Barcelona. At the corner of Avinguda de la Reina Maria Cristina, bus number 61 departs every half-hour for the Plaça Neptú at the very top of Montjuïc. If you decide to ride the bus up the hill, skip from here to the end of this walk and follow the same route in reverse coming down the mountain; at the end of your route you will be back at this spot and can take the Metro Espanya to your hotel. But walking up is pleasant; it is a short distance on the broad, grass-lined avinguda past large pavilions, constructed for the International Exposition of 1929, where the Catalan Congress now meets.

The park situated on Montjuïc—the Mountain of the Jews, former site of a Jewish cemetery—is 568 feet high and was

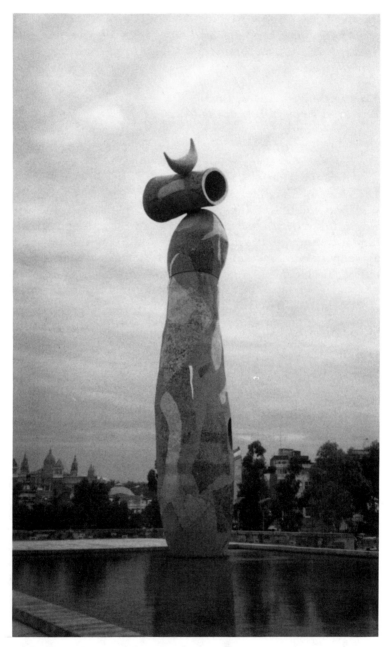

Sculpture by Joan Miró at Park Joan Miró. (Mary Ellen Jordan Haight)

completed in 1894 by architect Josep Amargós. The 696 acres of gardens were originally planted by the French landscaper Jean-Claude Forestier (1861–1930) and completed by Catalan landscape architect Rubió i Tuduri (1891–1981). A significant part of the mountain was built for the 1929 Exhibition.

Steps lead up to the Plaça de Carles Buïgas, named for the innovative engineer responsible for the fifty illuminated fountains on the Plaça de les Cascades nearby. Towering over everything is the Palau Nacional, opened in 1929, with Puig i Cadafalch as its primary architect.

2. Museu d'Art de Catalunya, Palau Nacional

The museum of Catalan art in the rear of the Palau Nacional has outstanding collections from Roman and Gothic times of the eleventh to the eighteenth centuries. These pieces were mainly collected from the tiny churches spread throughout southern Spain. The collection of Romanesque paintings is believed to be the most extensive and valuable in the world. Of special interest are the friezes of Pedret, Boi, Santa Maria, and San Clemente de Taüll from the twelfth and thirteenth centuries. Paintings include those of El Greco, Zurbarán, Ribera, and Viladomat.

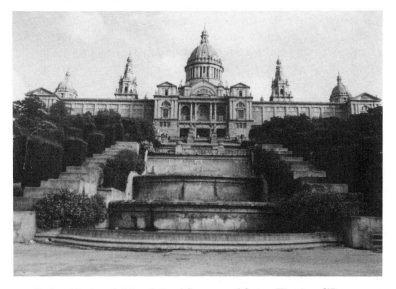

Palau Nacional, Montjuïc. (Courtesy Oficina Tècnica d'Imatge, Ajuntament de Barcelona)

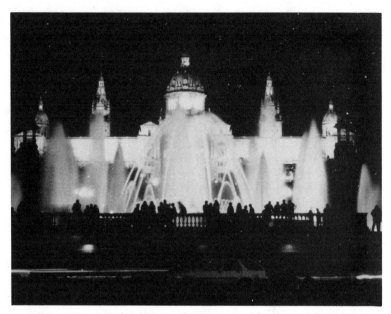

Fountains at Palau Nacional, Montjuïc. (Courtesy Oficina Tècnica d'Imatge, Ajuntament de Barcelona)

3. Museu de la Ceràmica, Palau Nacional

On the first floor of the palace, the ceramics museum contains a fine collection of ceramics including early primitive pieces from the Balearic Islands, glazed tiles from the eighteenth century, and modern contemporary works. The display shows the technical innovations and development of the art over the past eight hundred years.

Upon exiting the Palau Nacional, feel free to explore the area. There are numerous museums, plaças, and points of interest to delight and enthrall you here; we mention only a few that fit the scope of this book. To get to the next of these, when you leave the palace turn left onto Avinguda dels Montanyans to the fairgrounds, turning right just before the soccer field.

4. Pabellón Mies van der Rohe (Mies van der Rohe Pavilion)

This is a reconstruction of the building commissioned by the German government for the exposition, exact even down to a bronze copy of the sculpture by the German artist

Georges Kolbe that now hangs in the original's place. Ludwig Mies van der Rohe's work is considered the model for twentieth-century simple, spare architecture. This current German pavilion, a gift of the government of the Federal Republic of Germany, was built by Ignacio Sola Morales, who contributed to the controversy over the continuing construction of Sagrada Família. Although reinforced concrete was common in Gaudí's day, he rejected its use in the temple because stone was closer to nature and God. Specially made reinforced concrete is now being substituted for sandstone in interior walls and columns, but Morales stated that "Gaudí thought rock was important for a church. The use of concrete is an efficient falsification that goes against his ideas."

The next site is directly opposite.

5. Poble Espanyol (Spanish Town)

Built for the 1929 fair, the model Spanish town consists of a series of reconstructed houses, streets, and plazas typical of Spain's diverse past and cultures. Miguel Utrillo collaborated on the plans.

You can head in almost any direction here to reach the avenues ringing the area; if you feel tempted, explore. However, the quickest way to get to the next site on this walk is probably to retrace your steps to the Palau Nacional, turning right just before you reach it and wandering in that direction on the footpaths until you reach Avinguda de l'Estadi. Continue up the hill on it past the Olympic stadium, originally built for Barcelona's bid for the 1932 games and now remodeled and expanded for the summer Olympic games in 1992. Past the Plaça del Sol on your left is the next site, a large contemporary white building.

6. Fundació Joan Miró, Centre d'Estudis d'Art Contemporani

Hours: Tuesday to Saturday, 11A.M. to 7P.M.; Thursday open until 9:30P.M.; Sunday and holidays, 10:30A.M. to 2:30P.M.; closed on Monday (except holidays).

The Miró Foundation was created in 1971 by the artist to enable study, dissemination, and exhibition of his works. Miró donated a large number of his personal collection, some of which are on permanent display; and the center sponsors frequent temporary exhibitions on specific aspects of his art.

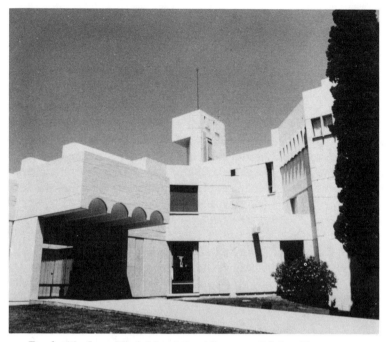

Fundación Joan Miró, Montjuïc. (Courtesy Oficina Tècnica d'Imatge, Ajuntament de Barcelona)

The foundation is also engaged in promoting contemporary art in general and exhibits art from all over the world, as well as shows by young artists, films and videos, recitals of contemporary music, and lectures and seminars on subjects of current interest in the art world. In a multimedia collection entitled *To Joan Miró,* artists from many countries contributed their works as expressions of admiration and friendship. The collection donated by Miró includes 217 paintings on canvas, paper, wood, and other supports, dating from 1917 to the 1970s; 153 sculptures; 9 textiles; his complete graphic works; and almost 5,000 drawings that trace the development of his talent from his first childhood sketches in 1901 to his last works.

Designed by Josep Lluís Sert in collaboration with Jaume Freixa, the foundation was opened on 10 June 1975. The outstanding feature of the modern design that evokes traditional elements of Spanish architecture is its light. Skylights flood the main exhibition areas with natural light, and large

windows link the white interior spaces with the exterior natural surroundings. Encircling patios and terraces are used for open-air displays. An octagonal tower houses the library and the auditorium used for lectures, seminars, music recitals, and film and video showings. Be sure not to miss the adjacent sculpture garden.

The Avinguda de Miramar in front of the museum runs down the hill to the funicular that descends to the Plaça Raquel Meller daily in the summer and on Sundays and holidays during the rest of the year. It will carry you to the Carrer Nou de la Rambla in the Chinese section, just one block closer to the sea than the Paral-lel Metro station. If the funicular is not running, it is a pleasant walk down the hill via the Avinguda de Miramar to the Passeig de Miramar, where you will overlook the bay and discover such interesting sites as a vast cactus garden on your way to Carrer Nou de la Rambla.

WALK SEVEN

THE SUN OF SITGES

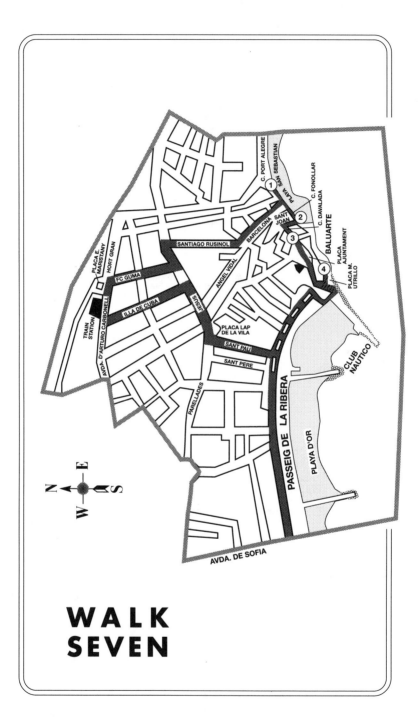

C. PORT ALEGRE
PLAYA SAN SEBASTIAN
SAN SEBASTIAN
C. FONOLLAR
C. DAVALADA
BARCELONA
SANT JOAN
BALUARTE
PLACA AJUNTAMENT
SANTIAGO RUSINOL
ANGEL VIDAL
PLACA M. UTRILLO
PLACA E. MARISTANY
HORT GRAN
FC GUMA
ILLA DE CUBA
JESUS
TRAIN STATION
AVDA. D'ARTURO CARBONELL
PLACA LAP DE LA VILA
SANT PAU
SANT PERE
CLUB NAUTICO
PARELLADES
PASSEIG DE LA RIBERA
PLAYA D'OR
AVDA. DE SOFIA

N
E
S
W

WALK
SEVEN

Frequent trains from Estació Barcelona Central-Sants run southwest along the coast of the Mediterranean on the forty-minute scenic ride in the direction of Vilanova and Tarragona to the village of Sitges.

Sitges is a picturesque beach town dating back more than two thousand years to before the arrival of the Romans in Spain. Remnants of medieval houses with beautiful Gothic-style windows can still be seen in the small town. Before becoming an international vacation site, Sitges was an important port for shipping wine and other regional products. Many of the nineteenth-century emigrants to the United States later returned with fortunes used to build Moderniste seaside mansions. The scenic winding streets of the center of town plus excellent weather, beaches, and a cosmopolitan and maritime flavor attract artists and intellectuals. Today it is referred to as the Cannes of Catalunya.

From the railway station at Plaça E. Maristany, walk south toward the sea on Carrer Guma for two blocks to Carrer Jesus, turn left and walk one block, then turn right onto Carrer Santiago Rusiñol, named for the resident poet, dramatist, actor, journalist, painter, impresario, and collector. Look for the colorful tile plaque on the corner building that denotes the street name with a sketch. At the five-way intersection, take the second street to your left—Carrer Barcelona—then turn left at Carrer Port Alegre.

1. Statue of Santiago Rusiñol

In a small park overlooking the Playa Sant Sabastià is a statue of the champion of Modernisme. Surrounded by tall old palm trees and century plants, the life-size figure of Rusiñol stands smoking a pipe and gazing out to sea just as he might have for a thousand days while living in his nearby seaside home. Enscribed on the base is "En Poble de Sitges a Santiago Rusiñol" (From the people of Sitges to Santiago Rusiñol). In 1892, Rusiñol and his cohorts held the first of five Sitges Moderniste celebrations to extol the new cultural attitudes underlying innovations in art, literature, music, and decorative arts. At the second Festa Moderniste, held in September 1893, Rusiñol, and a group of amateurs performed (in Catalan) *La intrusa,* a theatrical Symbolist piece by the poet and playwright Maurice Maeterlinck. Literature was emphasized at the third festa in 1894 with the literary contest of Cau Ferrat.

113

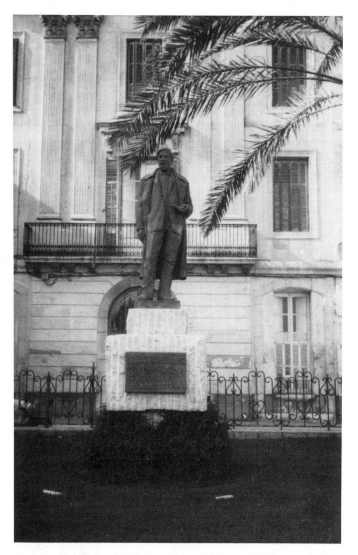

Statue of Santiago Rusiñol. (Mary Ellen Jordan Haight)

Sometime before they left together for Paris in 1900, Picasso visited Casagemas at his friend's mother's family villa overlooking Sant Sebastiá beach, after which they stopped for drinks of beer in several taverns.

Cross to the seawall and then go up the hill on the narrow Carrer Fonollar.

2. Home of Santiago Rusiñol
Carrer Fonollar, Museu Cau Ferrat

Hours: Tuesday to Saturday 9:30 A.M. to 2 P.M. and 4 to 8 P.M.; Sunday, 10 A.M. to 2 P.M. Closed on Monday.

The Mediterranean-style white house sits on a promontory overlooking the famous azure blue sea. Rusiñol loved the sea and, captivated by the light in Sitges, in 1894 he purchased two houses designed by Francesc Rogent for use as his home and studio. Rusiñol's decorative ideas, along with the

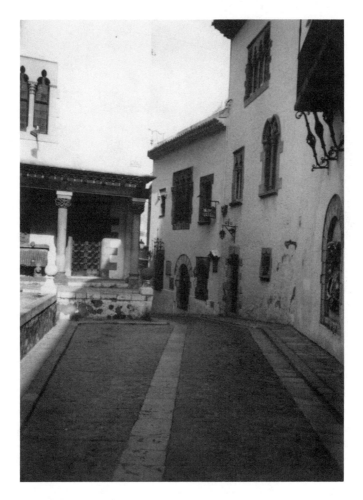

Museu Cau Ferrat. (Mary Ellen Jordan Haight)

Interior of Sitges, *painting by Rusiñol, 1894. (Museu d'Art Modern, Barcelona)*

help of Miguel Utrillo, converted the fisherman's cottages into a unique home in which he installed his collection of forged iron, ceramics, glass, furniture, paintings, and carvings. It was named Cau Ferrat (The Iron Lair) because of his collection of antique wrought-iron objects. Upon Rusiñol's death in 1931, the city of Sitges inherited the building and its contents but had difficulties financing its conversion to a museum. Under the direction of the new Patronato de Museu de Cau Ferrat, funding was received from many sources. The official opening was held in 1933; but one of the worst consequences of the Spanish civil war was the hindrance of support for the arts, and during that time work on the museum stopped completely. In 1966, the city of Sitges and the

Portrait of Rusiñol by Pablo Picasso, 1899–1900. (Courtesy Museu Picasso, Barcelona)

generalitat of Barcelona agreed to take over the direction.

Upon entering you will notice the stunning floors tiled in red, or blue and white. The bright blue is dramatic, especially in the rear sun room where the color of the water immediately outside is almost the same shade of blue. The display cases in this room hold archaeological artifacts of glass, ceramic, and bronze that pre-date Christ. They are from the Greco-Roman period on the island of Ibiza. In the main salon on this ground floor is a table where Rusiñol worked, along with his palette and a piano. Hanging above the writing desk is a Picasso oil, *Corrida de Toros* (The Bullring).

Rusiñol's bed is in a small room with a tiled washstand built into a corner. On one wall are the original charcoal

illustrations by Ramón Pichot for a book authored by Rusiñol. Up the stairs on the first floor, the grand salon contains a collection of forged iron candelabras, keys, lamps, crucifixes, candles, and a Catalan altarpiece dating from the first half of the fifteenth century. Lining the walls are paintings by Rusiñol, including a portrait of Sarah Bernhardt, and works by Casas, Nonell, Pichot, Utrillo, and his mother and sister. There are also two large oils by El Greco dating from the sixteenth century; Rusiñol acquired them in Paris in 1894. The cases hold old Catalan ceramic plates, bowls, basins, and pharmacy bottles.

Rusiñol and Casas were pioneers in the innovation of Moderniste Catalan painting. Sometimes referred to as the Spanish impressionists, they returned from their stays in Paris with an eclectic style that mixed French impressionism, art nouveau, and Symbolism and set off a revolution among the most conservative critics accustomed to pure realism. Their depictions of city street life, cafés, or the suburban towns and fields, captured in a transitory moment in time predominantly in shades of gray and blue tones, were examples of the new style of painting.

Perhaps the most important contribution of Casas and Rusiñol to the future of art was their influence on the young Picasso. Rusiñol's gloomy, morbid depictions of morphine addiction (for which he received treatment) are reflected in Picasso's early paintings of death and the desolate subjects of his blue-period works. The brightly styled portraits and posters drawn by Casas inspired Picasso's cheerful portraits of the members of the bohemian circle.

Walk down the tiny Carrer Sant Joan. On your right at number 5 the wall plaque states that in this white house lived a good artist of Sitges, Augusti Ferrar Piño, from the time of his birth in 1884 until 1896; he died in 1960. At the end of the block, turn left up the hill to the intersection of Carrer Davalada and the Plaça de l'Ajuntament.

3. Biblioteca Santiago Rusiñol

Hours: Monday to Friday, 10:30 A.M. to 12:30 P.M. and 4:30 to 8:30 P.M. on Saturday, morning hours only. Closed on Sunday.

In this library the papers of Rusiñol are collected for use by scholars and researchers. Not only was he a crucial per-

former in the intellectual struggle for contacts outside of provincial Spain, but he wrote poetry and plays that express the symbols, or realities, of the modern revolt against the church and government. At the Moderniste celebration in 1894, César Franck, the French composer, was honored along with Maeterlinck. After the excited Catalan poets and artists had carried Rusiñol's two El Greco paintings in a solemn procession through the winding streets of Sitges, Rusiñol delivered a fiery speech: "We prefer to be symbolists and mentally unbalanced, nay, even mad and decadent, rather than debased and cowardly; common sense stifles us, prudence in our own land is in excess. . . ."

Facing the Plaça de l'Ajuntament is the city hall, housed in a palace constructed for Bernardo de Fonollar, Count of Barcelona. The exterior was remodeled in the nineteenth century by Francesc Berenguer.

Continue around the pink church to the seawall and the Plaça Miguel Utrillo, where a plaque in honor of this artist and critic is placed on the wall of the Palau Blau. Like Ramón Casas and architect Puig i Cadafalch, Utrillo lived at various times in Sitges and he died here in 1934. Joaquim Sunyer i Miró, a member of the Catalan clique on Montmartre, was born in Sitges in 1875 and died here in 1958. Sunyer was the primary painter in the Noucentista group of artists and writers that, after 1906, reacted against the Moderniste style. Unlike Picasso, he soon returned to his life in Barcelona and Sitges.

4. Museu Maricel de Mar

Hours: Monday to Saturday, 10 A.M. to 1 P.M. and 4 to 6 P.M.; Sunday, 10 A.M. to 2 P.M.

In the fourteenth century, this was the Hospital de Sant Joan; later it became the residence of the Fonollar family. Chicago industrialist Charles Deering, an admirer of Ramón Casas, acquired it in 1900 and hired Miguel Utrillo to transform it into a home. About fifteen years later Deering, tired of his patronage of Casas, sold the property and much of its contents to move to an estate in Tarragona. He kept his large collection of works by the Spanish master artists, including the fantastic El Grecos now in the permanent collection of the Art Institute of Chicago. In 1970, thanks to the generosity of Dr. Pérez-Rosales, the house was opened as a museum and

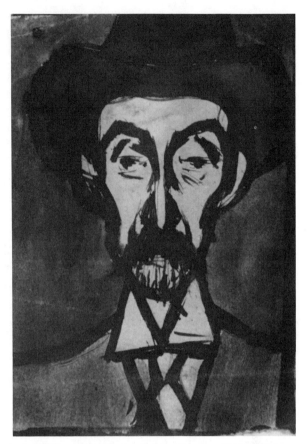

*Portrait of Miguel Utrillo by Pablo Picasso, 1899–1900.
(Courtesy Museu Picasso, Barcelona)*

many of the artworks and furnishings were replaced.

The rooms are filled with works dating from the ninth to the nineteenth centuries. Our focus is Sala VII, up the stairs and to the right through stunning salas to the room at the far end. On four walls, broken only by the door, are floor-to-ceiling murals painted by Josep Maria Sert in 1917. Representative of scenes from World War I, colored in greens and earth colors, the panels are trimmed in wide gold moldings. When Deering left this house, he took the murals with him. After his death, they were auctioned many times by various owners in many countries until purchased by Dr. Rosales. Muralist Sert lived most of his adult life in Paris and was the

Portrait of Isabel Llorach *by Ramón Casas. View of Sitges beach and church in background. (Museu d'Art Modern, Barcelona)*

third husband of the celebrated patron of the arts, Misia. Upon his death there, he left Misia his antique-filled apartment on the rue de Rivoli, where she died in 1950 in the company of her closest friends, Coco Chanel and Jean Cocteau.

Before ending your visit to Sitges, backtrack to the church and descend the steps in front of it to the Passeig de la Ribera along the Playa d'Or (Beach of Gold), where Casas pictured Isabel Llorach with the beach and church in the background in his 1901 painting. After a few blocks, you will find another iron fence enclosing a small grassy park in which stands a statue of El Greco, the sixteenth- and seventeenth-century Spanish painter.

Retrace your route on Passeig de la Ribera and turn left up the hill on Carrer Sant Pau, noting on your right Els 4 Gats restaurant, a tiny re-creation of the Barcelona café. Its walls are hung with copies of Picasso illustrations as well as interesting old newspaper clippings. When the street ends at Plaça Cap de la Vila, turn right and follow Carrer Jesus for two blocks, then turn left on Carrer Illa de Cuba. At the end of this street is the train station.

FAREWELL TO BARCELONA

Barcelona is Spanish, French, Italian, North African, and American; but above all, it is Moderniste. Modernisme can be considered the artistic culture of Catalanism: music, choral singing, poetry, and literature blended Catalan content with modern forms. In no other city did the new art movement rage more fiercely than here. Was it due to the very fertile soil of Catalunya or the special soft light about which artists spoke and wrote?

Barcelona had a rich cultural heritage of traditional Catalan arts and crafts in the latter years of the nineteenth century and a strong political independence movement. All of this in the environment favored innovations in the arts and literature. The Moderniste style was a success with the upper classes and, through architecture and decorative arts, became popular with all other classes as well. At the same time, the style was spreading throughout Europe. Furniture, jewels, fabrics, posters, books, publications—all of the products of the decorative and industrial arts, all of the areas in which artistic taste is manifest, felt the impact of the new art. The most internationally renowned Catalan representatives—Picasso, Miró, and Gaudí—showed a personal sense of fantasy that was rooted in the rich Catalan soil, as evidenced in a statement by Gaudí:

> The Catalans have that sense of plasticity—which gives the perception of objects as wholes as well as their relative placement. The sea and the light of the Mediterranean give this admirable quality and it is for this reason that real objects do not deceive the Catalans but instruct them.

All three were obsessed with the realization of their visions. Miró may have lived in Paris for a long period of time, but he returned to Barcelona and lived his final years on his mother's native island of Mallorca. As Gaudí's legacy, Barcelona probably contains more head-turning architectural miracles than any other European city. Gaudí's buildings provide the city with its strongest images. Irrespective of its artistic achievement, the Sagrada Família *is* Barcelona as much as Sacré-Coeur is Paris and the Empire State Building is New York City. In Spain, if not the world, Gaudí, architecture, and Barcelona are synonymous.

And of Spain's most famous modern artist, an expatriate for the majority of his life, Catalan Salvador Dalí stated:

"Picasso was a genius because he understood everything before anyone else. If the Spanish government wishes to honor him, it will put his picture on its thousand peseta bills." In 1938 Gertrude Stein wrote that, although the twentieth century is a time when everything cracks and is destroyed, the century is splendid—and then she made these prophetic remarks:

> It was natural that it was a Spaniard who understood that a thing without progress is more splendid than a thing which progresses. The Spaniards who adore mounting a hill at full speed and coming down the hill slowly, it is they who were made to create the painting of the twentieth century, and they did it, Picasso did it. . . . So then the twentieth century has a splendor which is its own and Picasso is of this century So, then Picasso has his splendor.

Barcelona also has this splendor. This is not farewell to Barcelona forever because the splendor and the *ambiante* are etched forever in our hearts and memories.

Arisa, J. J. Navarro. "Una esposición de Picasso en Barcelona rinde un homenaje 'familiar' a Jacqueline." *El País* [Madrid], 18 October 1990.

Ajuntament de Barcelona. *Barcelona Modernisme*. Barcelona: Patronat de Tourisme, 1988.

_____ *Barcelona: Carrers i plànols,* 5th ed. Barcelona: Ajuntament de Barcelona, 1989.

_____. *The "Quadrat d'Or" (Golden Square) Guidebook,* English ed. Barcelona: Regidoria d'Edicions i Publicacions, 1990.

_____. *Guia dels Museus de Barcelona.* Barcelona: Ajuntament de Barcelona, 1988.

Bailey, David. "Picasso and Me." *Vanity Fair,* February 1991.

Biographical Dictionary of Artists of Catalonia, Anals y 1897–1903. Barcelona: 1951.

Bottineau, Yves. *The Wonders of Spain.* New York: Viking Press, 1962.

Burns, Edward, ed. *Gertrude Stein on Picasso.* New York: Liveright, 1970.

Cabanne, Pierre. *Pablo Picasso: His Life and Times.* New York: William Morrow and Co., 1977.

Català-Roca. *Miró: Ninety Years.* London: MacDonald and Co., 1986.

Clavell, Xavier Costa. *Picasso.* Barcelona: Editorial Escudo de Oro S.A., 1987.

Collins, George, and Juan Bassegoda Nonell. *Antonio Gaudí: The Designs and Drawings of Antonio Gaudí.* Princeton, N.J.: Princeton University Press, 1983.

Corbett, Patricia. "Picasso's Masterpiece." *Connoisseur,* July 1988.

Dalí, Salvador. "De la beauté terrifiante et comestible de l'architecture modern style." *Minotaure,* no. 3/4 (1933).

"Dalya Alberge reports on a monumental marriage between Barcelona and New York." *The Independent* [London], 30 April 1991.

Descharnes, Robert, and Prévot Clovis. *Gaudí the Visionary.* New York: Dorset Press, 1982.

Fisher, Robert. *Picasso.* New York: Tudor Publishing Co., 1967.

Frampton, Kenneth, and Yukio Futagawa. *Modern Architecture 1851–1945.* New York: Rizzoli International Publications, Inc., 1983.

Frisach, Montse. "Una mostra remarca la presència constant de Jacqueline Picasso a l'obra del pintor." *Avui* [Barcelona], 18 October 1990.

George-Michel, Michel. *From Renoir to Picasso.* Boston: Houghton Mifflin Co., 1957.

Gérard, Max, ed. *Dalí*. New York: Harry N. Abrams, Inc., 1968.

Glimcher, A., and C. Glimcher, eds. *Je Suis le Cahier: The Sketchbooks of Picasso*. New York: The Atlantic Monthly Press, 1986.

Güell, Xavier. *Antoni Gaudí*. Barcelona: Editorial Gustavo Gili, S.A., 1990.

Haight, Mary Ellen Jordan. *Paris Portraits, Renoir to Chanel: Walks on the Right Bank*. Salt Lake City: Gibbs Smith, Publisher, 1990.

Hamlyn, Paul. *A Field Guide to Landmarks of Modern Architecture in Europe*. Englewood Cliffs, N.J.: Prentice-Hall, Inc., 1985.

Hayward Gallery. *Homage to Barcelona: The City and Its Art*. London: Arts Council of Great Britain, 1985.

Hernández-Croz, Josep Emili, Gabriel Mora, and Xavier Pouplana. *Guia de Arquitectura de Barcelona*. Barcelona: Plaza i Janés Editores, S.A., 1987.

Hitchcock, Henry-Russell. *Architecture: Nineteenth and Twentieth Centuries*. New York: Penguin Books, 1958.

Huffington, Arianna Stassinopoulos. *Picasso: Creator and Destroyer*. New York: Simon and Schuster, 1988.

Hughes, Robert. "Modernism's Neglected Side." *Time,* 13 August 1990.

Irving, Washington. *A History of the Life and Voyages of Christopher Columbus*. London: John Murray, 1828.

Jordi, Enric. *Historia de Els 4 Gats*. Barcelona: Biblioteca Biografica Catalana, Edicorial Aedas, 1986.

_____. *Nonell*. Barcelona: Edicions Poligrafa, S.A., 1984.

Jouffoy, Alain. *Miró*. New York: Universe Books, 1987.

King, Julia. *The Flowering of Art Nouveau Graphics*. Salt Lake City: Gibbs Smith, Publisher, 1989.

Lake, Carlton. *In Quest of Dalí*. New York: G. P. Putnam's Sons, 1966.

Lassaigne, Jacques. *Miró*. Paris: Editions d'Art, 1963.

Livesey, Herbert Bailey. "Barcelona Rising to New Heights." *Travel and Leisure,* June 1990.

Mackay, David. *Modern Architecture in Barcelona, 1854–1939*. Sheffield, Eng.: Anglo-Catalan Society, 1985.

Macmillan Encyclopedia of Architects. New York: The Free Press, 1982.

Marnham, Patrick. "Gaudy, Bawdy Barcelona." *New York Times,* 4 March 1990.

Mellow, James R. *Charmed Circle*. New York: Avon Books, 1975.

Mower, David. *Gaudí*. London: Oresko Books, Ltd., 1977.

Museum of Modern Art. *Pablo Picasso: A Retrospective.* New York: Museum of Modern Art, 1980.

_____. *Picasso, Gris, and Miró: The Spanish Masters of Twentieth-Century Painting.* San Francisco: Museum of Modern Art, 1948.

Museu d'Art Modern. *El Modernisme.* Barcelona: Olimpíada Cultural, 1990.

Orwell, George. *Homage to Catalonia.* New York: Harcourt Brace and Company, 1969.

Penrose, Roland. *Miró.* New York: Harry N. Abrams, Inc., 1970.

_____. *Picasso: His Life and Work.* New York: Schocken Books, 1962.

Potok, M., P. Harsh, M. Aparicio, and M. Unceta. *Barcelona.* Lincolnwood, Ill.: National Textbook Co., 1987.

Raeburn, Michael. *An Outline of World Architecture.* London: Octopus Books, Ltd., 1978.

Richardson, John. *A Life of Picasso.* New York: Random House, 1990.

Rubin, William, ed. *Pablo Picasso: A Retrospective.* New York: The Museum of Modern Art, 1980.

Sabartés, Jaime. *Picasso: An Intimate Portrait.* New York: Prentice-Hall, Inc., 1948.

Schumacher, Edward. "How Public Sculptures Are Giving Barcelona a Bright New Look." *New York Times,* 4 September 1990.

Schumacher, Edward. "The 'Disneylandia' Debate." *San Francisco Examiner,* 13 January 1991.

Shrady, Nicholas. "Barcelona." *European Travel and Life,* April 1987.

Sitges. Barcelona: Editorial Escudo de Oro, 1989.

Solà-Moreales, Ignasi de. *Jujol.* New York: Rizzoli, 1991.

Stein, Gertrude. *The Autobiography of Alice B. Toklas.* New York: Harcourt Brace and Co., 1932.

_____. *Picasso.* London: B. T. Batsford, Ltd., 1938.

Swick, Thomas. "Exploring Barcelona before the Olympics." *San Francisco Examiner,* 22 April 1990.

Toklas, Alice B. *What Is Remembered.* San Francisco: North Point Press, 1985.

Walther, Ingo F. *Picasso: Genius of the Century.* Cologne: Benedikt Taschen Verlag Gmbh und Co., 1986.

Waugh, Evelyn. "Gaudí." *Architectural Review,* 67 (June 1930).

Wells, Patricia. "Barcelona for Food Lovers." *Travel and Leisure,* June 1990.

ACKNOWLEDGMENTS

We are pleased and grateful to thank the following people for their assistance:

In San Francisco, Elpidia Garcia cheerfully translated phrases and quotes from Spanish and Catalan into English. Dorothy V. Mayers, librarian at the Park Branch of the San Francisco Public Library, searched for publications and reminded us of the importance of the public library system. Wanda Marie Haight rescued us from computer emergencies and Betty Kennedy Haight and Joanne Haight made the project a family affair with their support and enthusiasm.

In Barcelona, Margarita Ferrer of the Museu Picasso; Sylvia Domènech, Oficina Técnica d'Imatge, Ajuntament de Barcelona; Mercé Doñate, conservator of the Museu d'Art Modern; Prof. Dr. Juan B. Nonell, Gaudí chair, Catedra Gaudí; and Rafel Torrella, Arxiu Fotogràfic de Museus, Ajuntament de Barcelona were extremely helpful in the acquisition of photographs. Jordie Muñoz, Xavier Güell Guix, and Elena Pujol Herrick, cultural attaché, at the United States consulate, unselfishly contributed their time and knowledge.

Publishers Gibbs and Catherine Smith had the imagination and faith this project needed. Editorial director Madge Baird has become a seasoned armchair traveler while directing the meticulous editing of Elizabeth W. Watkins as we all wrestled with unfamiliar Catalan words. Mary Ellen Thompson performed miracles by transforming our crudely drawn maps into easily followed routes.

INDEX

de Soto, Angel Fernándo, 33, 46
de Soto, Mateu Fernándo, 34, 46
de Taüll, San Clemente, 105
de Vilató, Lola Ruiz Picasso, 20
Deering, Charles, 119–20
Domènech, Lluís (the son), 64
Domènech, Pere, 71
Domènech i Estapá, Joseph, 64–5, 79
Domènech i Montaner, Lluís, vii,
 39–40, 44, 49, 61, 75, 81;
 designs, 16, 25–6, 36, 42, 59–60,
 64, 71, 80, 82, 83, 88
Dona i Ocell, 103

Eden Concert, Café, 33–4
El Greco, 105, 118, 122
Els Quatre Gats, 22, 35–6, 44–6
Escofet, 60
Escuela Provincial de Architecture de
 Barcelona, 8
Escuela Superior de Arquitectura, 52
España, Hotel, 36–7
Espriv i Castello, 72

Falqués i Urpí, Pere, 60, 71
Farreras, Francesc, Casa, 81
Fatjó i Torras, Enric, 85
Ferrés i Puig, Eduard, 72
Fluxa, Fotaqts, 27
Fontserè i Domènech, Josep, 12
Fontserè i Mestres, Josep, 12, 24, 27
Forestier, Jean-Claude, 105
Fossas i Martínez, Juli, 80
Freixa, Jaume, 108
Frugal Repast, The, 23
Fuster, Consol Fabra de, Casa, 71

Gali, Francesc, 15
Gallissa i Soqué, Antoni, 83–4
Gamot, 27
Gargallo, Pau, 17
Gaudí, Museu, 99–100
Gaudí i Cornet, Antoni, vii, viii, 15,
 23, 24, 31, 36, 46, 49, 52, 58, 75,
 107, 123; designs, 7–8, 10, 12,
 16, 27, 32–3, 34, 39–40, 51,
 55–56, 61–4, 65–9, 85–8, 93–9
Geiser, Bernard, 23
Generalitat, Palau de la, 17
Gilbert, Farmacia, 52

Gili i Güell, Antoria, 38
Gorrigo i Roco, 37
Goya, Francisco, vii
Gran Teatre del Liceu (Opera
 Theater), 37–8, 60
Grana y Arrufi, Lluís, 39
Grandpierre, 70
Granell i Manresa, Jeroni, 60, 80,
 82–3, 84
Graner i Prat, Josep, 84
Grau, Charles, 12
Guernica, x, 16
Guinera, Angel, 38
Güell, Palau, 32
Güell, Parc, 95–9
Güell i Bacigulpi, Count Eusebio, 8,
 31, 32–3, 56, 95, 99

Hemingway, Ernest, 15
Homage to Picasso, 23
Homar, Gaspar, 56, 60, 79

Iglesias, Josep M., 81
Interior of Sitges, 116

Jacob, Max, 23
Jujol i Gibert, Josep Maria, 62–4, 66,
 68, 81, 83, 84, 98, 99, 103
Junyent, Oleguer, 56
Junyer i Vidal, Sabastià, 23, 46

Kolbe, Georges, 107

La Celestina, 31
La Deesa, 51
La Escolera, 31
La Llotja (*see* Academia Provencial de
 Bellas Artes de la Llotja)
La Pedrera (*see* Milà, Casa)
Larbata, 89
Las Meninas, 20
Last Moments, 36
Le Moulin de la Galette, 36
Les Demoiselles d'Avignon, 13
Llimona, Josep, vi, 19, 46
Llorach, Isabel, 121–2

Macaya, Casa, 85
Madorell i Ruis, Miguel, 81
Maeght, Gallery, 22